LAUNCESTON

From Old Photographs

LAUNCESTON
From Old Photographs

JOAN RENDELL

Additional Text and Pictures by John Neale

AMBERLEY

First published 2012

Amberley Publishing
The Hill, Stroud
Gloucestershire, GL5 4EP

www.amberley-books.com

British Library Cataloguing in Publication Data.
A catalogue record for this book is available from the British Library.

ISBN 978 1 84868 283 2

Typeset in 10pt on 12pt Sabon.
Typesetting and Origination by Amberley Publishing.
Printed in the UK.

Contents

Introduction

This book is slightly different from usual local history volumes. It is largely based on personal memories and we all know memories can play tricks but those absorbed in early age usually stick and so we think and hope that our early memories are quite authentic. Wherever possible I have verified them but sadly, as the years pass one's contemporaries pass on also and many Launcestonians from the days of which I have written are no longer with us.

However, if the reader is too young to remember some of the people and incidents mentioned, it is hoped that they will still find it entertaining and will accept my word for it being a true record of Launceston in the past.

Joan Rendell
Launceston, 2009

Launceston From Old Photographs is my friend Joan Rendell's book, on which she was working at the time of the tragedy. When I was asked, out of the blue, if I could provide additional text and images for this book I considered it a singular honour, a privilege and a challenge. I trust I have done the project full justice: Joan and her beloved Launceston deserve nothing less!

John Neale
Launceston, 2012

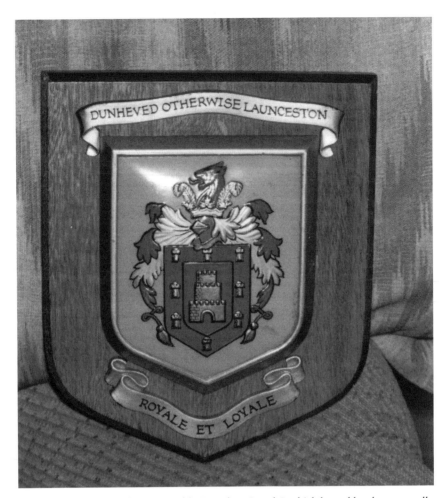

Launceston has always been staunchly 'Royale et Loyale', which legend has been proudly displayed on the Borough Arms since the visitation to Cornwall of one Robert Cooke, alias Clarencieulx, the herald. In July 1573 he came to Launceston, one of the more important places on his extensive itinerary. In keeping with the occasion, the Mayor, aldermen and Corporation waited upon the principal 'King of Arms'. Apparently he inspected the existing Common Seal and was not overly impressed. Afterwards he drew a new design, incorporating aspects of the former, principally the castle. This was surrounded by eight bearings, surmounted by a helmet, supported on either side by stylised leaves. Above this is a crown, the lion form the arms of Richard earl of Cornwall and the ostrich plumes from the badge of the Heir Apparent. The whole design of the arms, shown in red, blue, silver, gold and black, were granted to the town and since that time the Corporation have been allowed to bear and show them forever at their liberty and pleasure, without let or interruption. Long may they continue to do so! (Photograph: John Neale collection)

I

Buildings & Landmarks

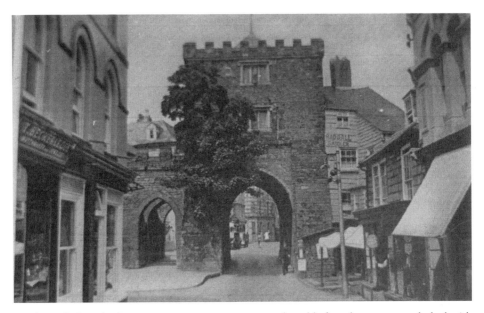

Southgate before the famous sycamore tree was removed, and before the town was choked with cars and other traffic.

Launceston is a very ancient town and at one time a place of immense importance but those glory days have long gone. It was the county town until the role was moved to Truro, since which time Launceston's contemporary importance has gradually diminished. This chapter looks at some of the key buildings that encapsulate the town's historical importance – both the prominent and the little-known.

Exploration of Launceston is not complete without a visit to the castle. The former custodian's cottage now houses a museum and a shop where guidebooks etc. can be purchased and there are interpretation boards beside the footpath, which help to give one a vivid idea of the appearance of the original castle complex, not that there was any word to describe it thus in its early days!

The castle dominates the town and is an iconic symbol of the treasures to be found in Cornwall. It came into being in the early days of the Norman Conquest and is a reminder of feudal power and the status of its owner.

When William the Conqueror succeeded in his invasion he rewarded his half-brother and one of his strongest supporters in the invasion, Robert of Mortain,

with the Earldom of Cornwall. Robert became one of the most powerful figures in the kingdom with vast estates in twenty counties, but his greatest strength was in Cornwall and the spot where he chose to establish his court and the administrative centre of his earldom was Launceston, which overlooked the Kensey valley with panoramic views that would allow plenty of warning of any attack from the east. The first historical reference to the castle is in the *Domesday Book*, which was completed in 1086. At that time the name for Launceston was the Saxon 'Dunheved' and the original name is still preserved in a number of ways. As Robert chose to build his castle at that location, the town of Launceston grew up around it.

A modern view across the Kensey Valley.

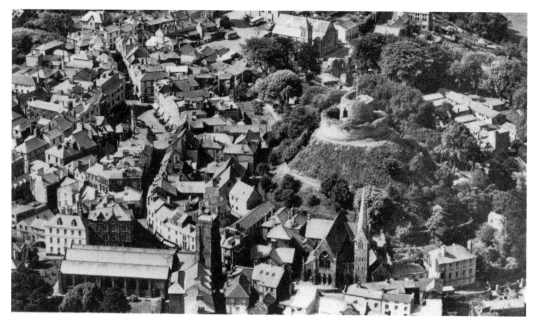

An aerial view of Launceston town centre as it was in 1954. Several landmarks are easily recognised: St Mary Magdalene church, 'Big Wesley' chapel, the castle, the square with the war memorial and the town hall, with the old sheep market beyond.

The medieval Yeolmbridge over the River Ottery, thought to be the oldest bridge in Cornwall, is a tangible sign of the long history of the area. Here we see the intensive strengthening work carried out in the 1980s that the bridge might continue its service.

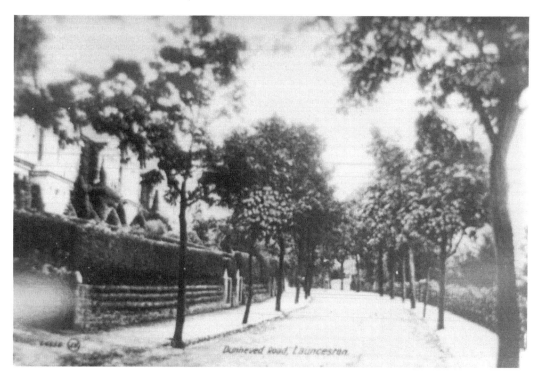

Dunheved Road and College take their names from the Saxon settlement that preceded the Norman castle and the settlement of Launceston that we know today. In November 1869, so the *East Cornwall Times* reports, many visitors come to Launceston and are so taken up with the town that many of them express a wish to live there. The only problem highlighted by the report is the shortage of housing. Seemingly Mr Dingley saw an opportunity and formed what could loosely be termed as a syndicate to cut a road from the Western Subscription Rooms (Now the *Cornish Devon Post* and *Launceston Weekly News* building) to Badash Cross. The new houses were to be favoured with a view which residents in the suburbs of many large towns would envy, so from the outset Dunheved Road was one of the most desirable roads in which to live.

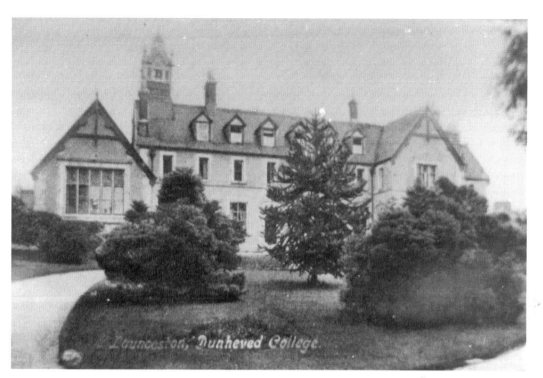

Dunheved College was built in 1873. The range of main buildings, including the assembly hall, classrooms, the headmaster's quarters and the boarders' accommodation, front onto Dunheved Road. An old prospectus states that there were new buildings, to include classrooms, in 1931. There was a well equipped science laboratory, a music room where the orchestra would meet, a library of several thousand books and a large gymnasium. In 1991 the iconic turret was restored and rebuilt. The college continues to grow, and in February 2006 a new £225,000 lottery-funded sports facility, or MUGA (multi-use games area), was opened by Mr Gerald Smith, the town's Mayor.

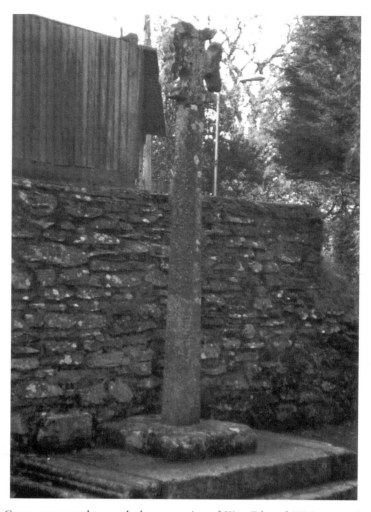

Dunheved Cross was erected to mark the coronation of King Edward VII in 1902. Some years previously the cross head had been discovered near the Alexander slate quarry at Tresmarrow, from where it was rescued by members of the Launceston Historical & Scientific Society and taken to the town museum. A length of octagonal chamfered cross shaft in Elvan stone with two iron hooks leaded into it, having once been used as a gatepost, was found leaning against a linhay at Badash Farm. A third large piece of Elvan stone about three feet square with a hole in the middle had for many years stood, on its side, forming part of a hedge near Badash. Detailed measurements were taken and drawings and comparisons made: the pieces all fitted together. Diagrams were sent to Mr Coode of Polapit Tamar, the then owner of Badash Farm. Apparently his interest in the old cross, believed to date from between 995 AD and 1085 AD, was fired. He agreed to finance the restoration project, which included two moulded base stones, and also the cost of its erection as near as possible to its original position. At one time the ten-foot-high cross had base stones and quoins with chains for protection, but over time these seem to have disappeared. The *Launceston Weekly News* reported that the inscription reads: 'This cross was erected at the cost of R. C. Coode, restored and replaced near its original site on the Coronation Day of King Edward VII 1902'. From that time until 1974, the cross stood near the end of Dunheved Road. When the bypass was being built it was removed for safety. Today it stands beside a footpath, beyond the pedestrian bridge over the bypass at the end of Dunheved Road and the doctors' surgery.

Dunheved Road, a popular residential area of the town, which can no longer boast so many trees and grassy areas. This picture was taken in 1805. A number of flowering cherry trees were planted in 1950 by Mr Stuart Peter, the then Launceston Town Clerk, to mark the unique family record of supplying town clerks to the town over many years.

Dunheved Road in 1865. The wooded area in the centre has long since disappeared.

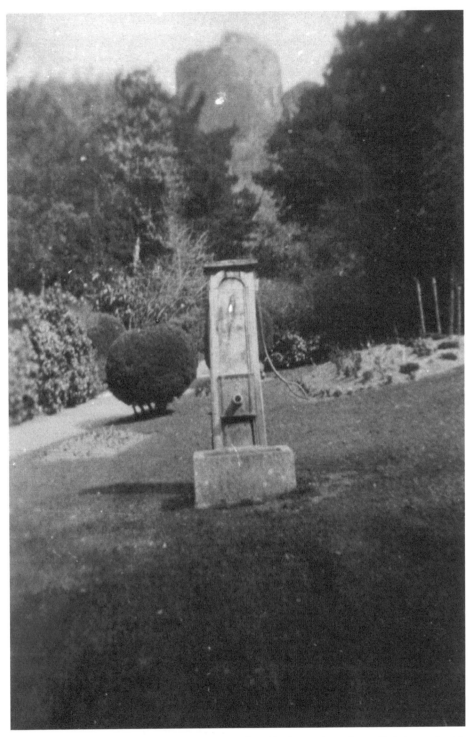

The old pump originally stood in the prison yard inside the castle and supplied the gaol with water. It is thought to be of eighteenth-century date.

All that we can see of the castle today are the half-natural half-artificial high motte with its stone keep, the ruined north gatehouse, the south entrance and some lengths of stone curtain wall. Excavations in recent years have revealed remains of the moot hall and other features of the domestic arrangements on the site, but by and large it is difficult to envisage what it must have been like in its heyday.

In the eighteenth century a prison was established there and remained until its demolition in 1842. A relic of these days is the prison pump that originally stood in the prison yard, an area which was later turned into pleasant grounds – very different from the days when hangings took place within the castle bailey. The last such event is believed to have been in 1821. A public footpath now runs between the south and north gatehouses, and the castle welcomes many visitors.

Mr Tolman lived in the custodian's cottage in the castle grounds and was responsible for keeping the grounds and the castle motte in good order, a job that he did magnificently. In his time the castle grounds had flowerbeds and shrubs, unlike today when they are mostly grassed and far less labour-intensive. Mr Tolman used to cut the grass on the steep motte by lowering a hand lawnmower on the end of a long rope. It kept it in impeccable order and how he ever managed it was something of a miracle; it must have been dreadfully hard work but he never complained and made it look so easy. Mr Tolman's wife was a keen flower-arranger and did some lovely decorations in St Mary Magdalene Church.

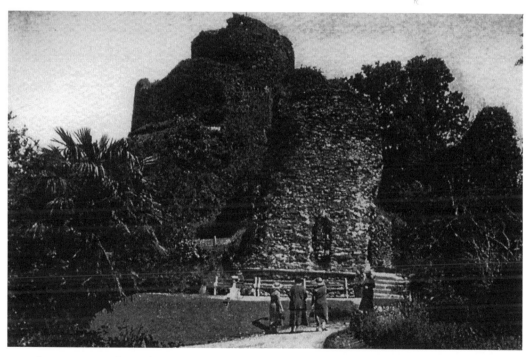

Launceston Castle, in the motte-and-bailey design, dominates the town. Standing proud on its mount it can be seen for miles around from the area between Dartmoor and Bodmin Moor. Once it had a fearful reputation and was generally known as 'Castle Terrible'. In Norman times it was a reminder to the townsfolk as to just who was master hereabouts. This pleasant spot beneath the castle keep was known as Paradise and seats were provided for the public to enjoy the grounds.

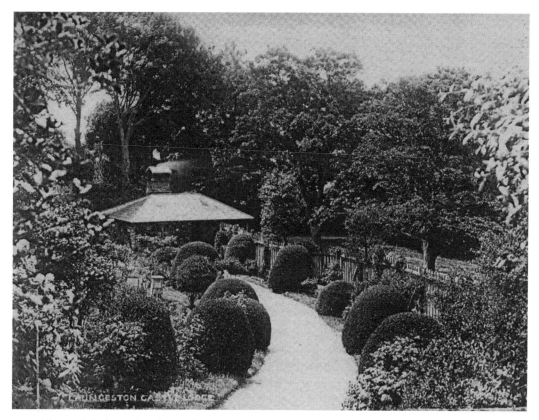

The castle lodge within the castle grounds, in the 1930s. The custodian of the castle lived here. The grounds are no longer filled with shrubs and plants, and the lodge now houses a small museum of artefacts and an English Heritage shop.

Opposite above: The Witch's Tower at Launceston Castle. The ford no longer exists being replaced by a busy road into the town centre and the tower is now just a heap of stones covered in grass.

Opposite below: Launceston Castle has dominated the town and district for centuries. During the Civil War the castle was greatly prized due to its strategic position – the River Tamar could be crossed here with little risk of losing men or equipment. During the Second World War and for some time afterwards there were government buildings on the lower part of the green. In living memory much of the formal gardens and shrubbery has been swept away, giving a much clearer view of the castle motte and keep we see today.

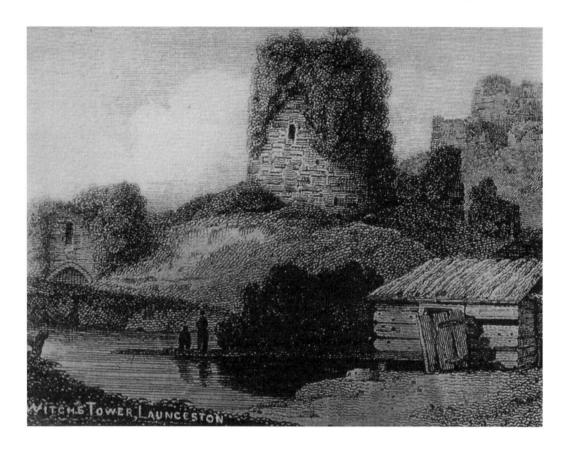

WITCHS TOWER, LAUNCESTON

19

The south entrance to the castle grounds. The gate was removed in the 1940s or '50s.

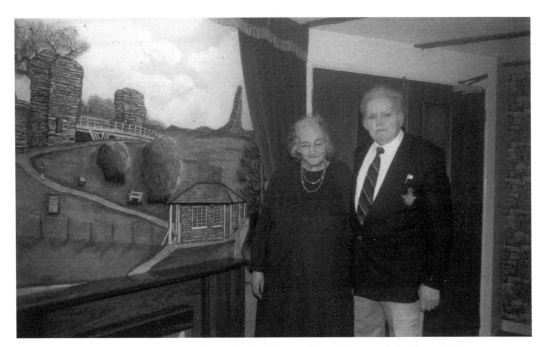

Mr and Mrs Colwell at the unveiling of a hand-painted mural by Mr Colwell, a gifted amateur artist. The scene is a familiar one in the castle grounds. During the period of the town hall refurbishment the painting was removed for safety to the Market House Arcade, where it remains on display today.

The late Mr Maurice Colwill's mural when it was in Launceston town hall.

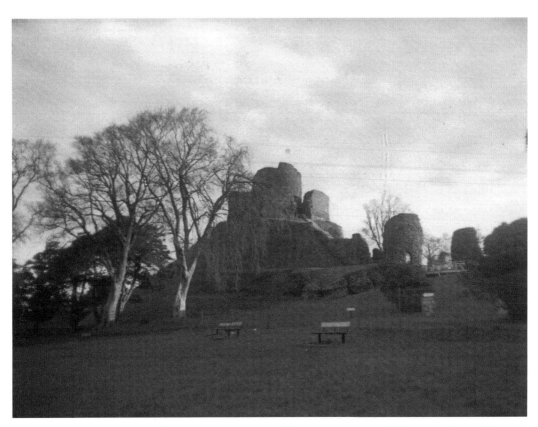

The castle and green as they were in 2007. Viewed from certain parts of the town, the castle's 'high tower' has a distinct lean away from the perpendicular. At one time it was feared that it would collapse and urgent remedial work was undertaken. In the 1960s a number of seasonal archaeological digs took place in the grounds, yielding numerous artefacts. Today, Launceston Castle is managed by English Heritage. From time to time special events have taken place on the green, as in 1889 when Mr Gladstone spoke to an estimated 10,000 people of the Liberal persuasion here. More recently, in September 2003 the Cornish Gorsedd was held here for the first time in over thirty years, with over four hundred blue-robed Cornish Bards gathering for their annual ceremony. The castle green is the venue for the castle's annual rock concert. On a more serious note, it also serves as one of the landing places available to the Cornwall Air Ambulance.

The town hall as seen through the north gatehouse entrance to the castle. This view is unchanged. The Feudal Dues were presented to HRH the Duke of Cornwall here in 1973. During the winter of 2010/11, there was some concern after a large piece of stone fell from the main arch as a result of frost damage. Hasty remedial work saved the structure from possible collapse. The town hall is a Listed Victorian Gothic structure with striking stained-glass windows and clock. It was built in 1887, while the guildhall, alongside it, is of a slightly earlier date. The clock was in fact originally a feature of the guildhall. The town hall served as a hospital during the First World War. Both buildings have recently undergone renovation work.

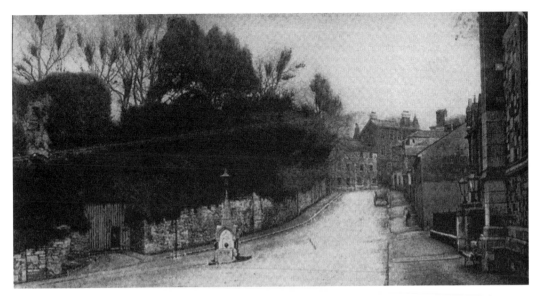

Guildhall Square and the south entrance to Launceston Castle, in the early 1900s. The Hender memorial fountain was demolished after the Second World War and parts of it re-erected at Windmill Recreation Grounds. The buildings seen on the right in the above photograph have long-since been demolished and the site redeveloped.

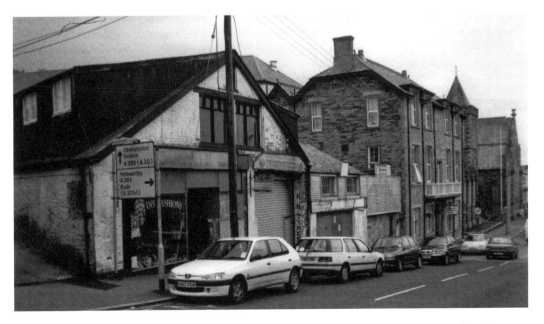

Wooldridges and the J. B. Smith Garage office block in Western Road. All of this range of shabby buildings has been demolished and the site is likely to be developed in the near future. The only remaining building on this side is the distinctive Conservative Club, dating from 1914. The Guildhall and Town Hall are glimpsed just beyond the road junction. The unsightly power cables that formerly stretched across the view of the Guildhall façade were removed in 2008 and laid underground. (Photograph: John Neale collection)

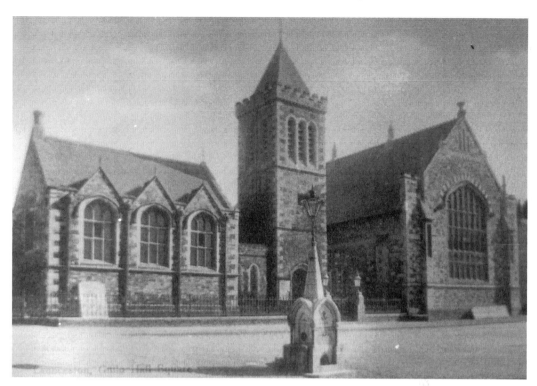

The Guildhall was built in 1881 and the Town Hall in 1887. In February 2005 plans for new development were made available to the public for comment. The Hender memorial fountain in the centre of the picture was erected by G. S. and T. B. Hender in remembrance of their son Leonard Macleod Hender, who tragically drowned near Land's End in 1894 at the age of eighteen. The Memorial was later removed and dumped at the slate quarry during a road improvement scheme! Fortunately, some of the remains were rescued by Launceston Old Cornwall Society and placed by the reservoir at the windmill.

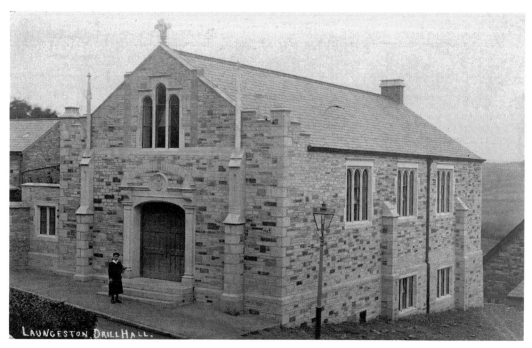

The Drill Hall in Westgate Street was opened in October 1907 on the site of some derelict cottages known as 'Noah's Ark', which had been purchased from the town council for £250. Money was short at the time but fortunately Mr C. J. Williams of Weerrington Park made and £800 interest-free loan available so that building work could commence. The hall was built for C Company (Launceston) and 2 Voluntary Battalion DCLI (Duke of Cornwall's Light Infantry). Today the Drill Hall is known as the Westgate Centre. (Photograph: John Neale collection)

Opposite below: The Jubilee Inn stood at the top of Castle Street where it converges with Northgate Street. The Jubilee closed down in December 1909. After that time several families lived there. It was finally demolished in the 1960s as part of a slum clearance scheme. Today the area is a small car park.There is much of historical interest here. John Betjeman was an admirer of the red-brick Georgian houses, declaring them to be some of the best examples in Cornwall. Nowadays, the community market takes place here every Friday, in the Methodist church hall.

Looking down Windmill Hill to Moffats' Tenement. It is now a solicitor's office. The holly tree shown still flourishes in the garden there.

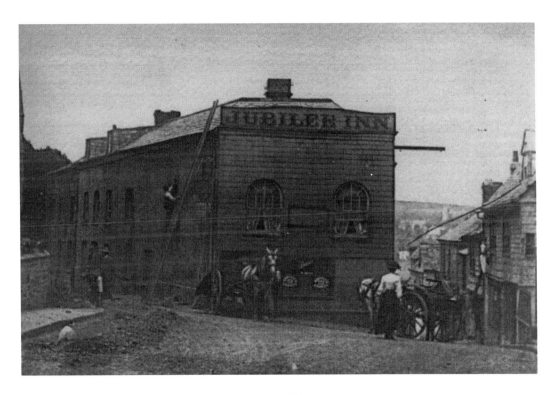

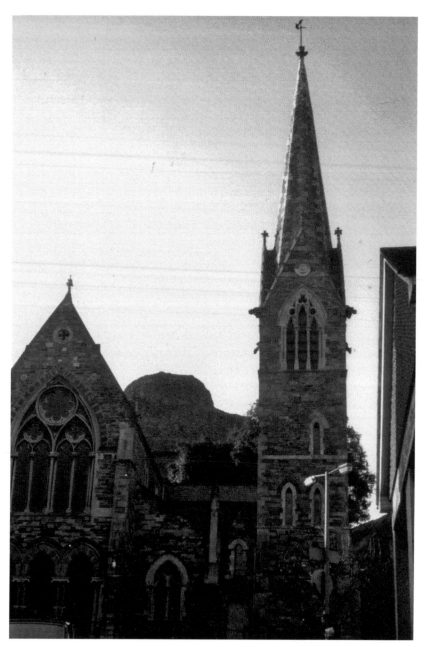

In November 1995 the Wesleyan chapel, fondly remembered as 'Big Wesley' and known today as the Central Methodist church, celebrated its 125th anniversary year. The current building is the third chapel on the site. It was built in 1870 of Polyphant, a porous stone. In January 1984 it was discovered that the spire was in urgent need of attention and that it would cost in the region of £30,000 to repair. After lengthy discussion the cost was deemed prohibitive, and the tower that had long been a town landmark was demolished later the same year. The cross that formerly topped the spire was re-sited at the base of the tower and re-dedicated. (Photograph: John Neale collection)

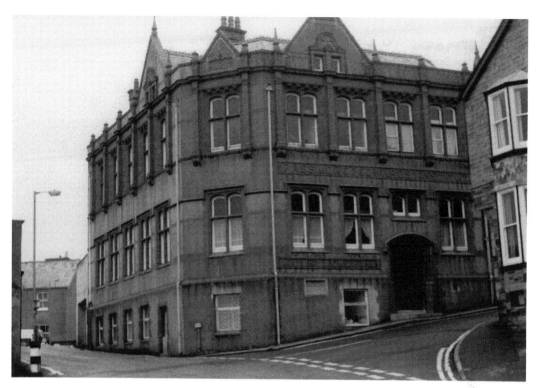

The Passmore Edwards Free Library and Technical Institute in Northgate Street was opened in April 1900. It was dedicated to the memory of local man Professor John Couch Adams, the celebrated astronomer who discovered Neptune. The building, of Polyphant stone and red brick, cost around £1,000. The architect of what was described at the time as a striking building – it still is – was Mr Sylvanus Trevail. Mr M. B. Moulton QC MP opened the building, which incorporated a magazine room and a newsroom. On the upper floor there were rooms for science and art classes. There was accommodation provided in the basement for a caretaker. Since the new library opened in Bounsalls Lane the old library has been turned into a block of flats. (Photograph: John Neale collection)

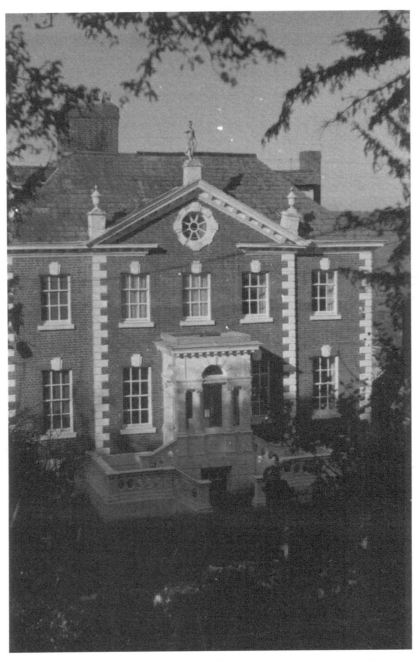

Eighteenth-century Eagle House was built by Mr Corydon Carpenter with money reputedly won in a lottery. It was the home of the Dingley family who were bankers in the town. The eagles on the gateposts are particularly striking and are reputed to fly down to the River Kensey at midnight to drink. Today Eagle House is a family-run hotel.

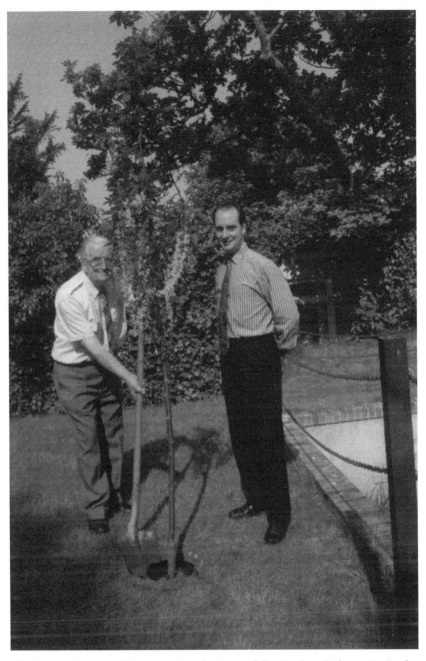

The late Mr Austin Robbins, founder chairman of the Dunheved Flower & Garden Group, is assisted by Mr Andrew Statton of Eagle House Hotel in planting in the hotel garden a tree presented by the group.

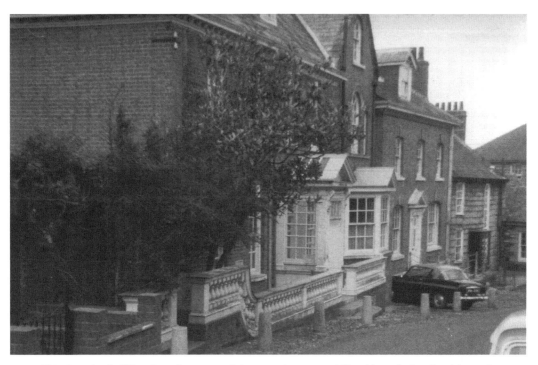

This Georgian building dates from 1753. Prisoners of war were billeted here during the eighteenth- and nineteenth-century wars with the French, because these were the largest houses in the town and thus were able to accommodate the numerous prisoners. It is now the Lawrence House Museum, devoted predominantly to local history as well as Launceston's links with Australia.

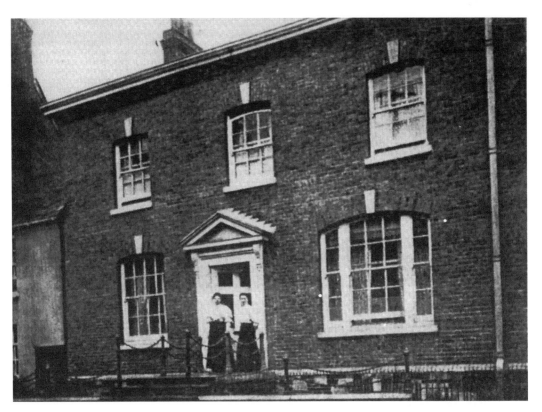

Miss Caroline Pearce and Miss Margaret Rundle are seen standing in front of No. 11 Castle Street, another fine Georgian residence. Miss Pearce was the daughter of Thomas Pearce and she had the house built. Miss Rundle was the daughter of Miss Pearce's butler.

Opposite below: Tower Street chapel, constructed originally for the Bible Christians was built for £750. It opened in 1851, but in 1897 a larger chapel was built on a nearby site and the original chapel became a Sunday school. In 1974 the idea was floated that the Tower Street congregation should merge with that of the Launceston Methodist church, fondly known as 'Big Wesley'. Lengthy discussions took place, and eventually its congregations recommended amalgamation and closure. At the time of the amalgamations 'Big Wesley' was officially renamed the Central Methodist church. The Tower Street chapel building was demolished in 1982. (Photograph: John Neale collection)

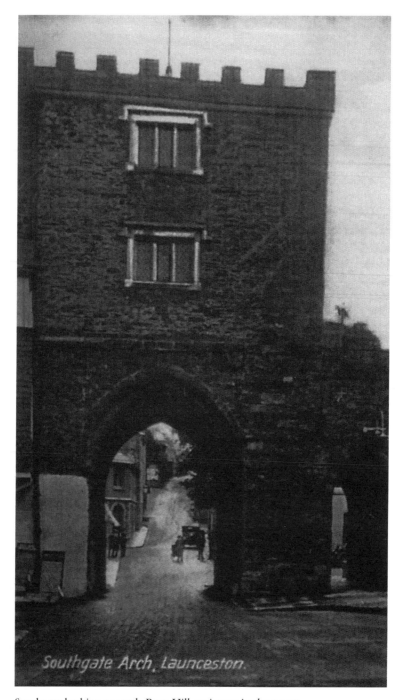

Southgate looking towards Race Hill, as it was in the 1930s.

Launceston was a walled town and the remains of that wall can still be seen in places. Access was by gatehouses. There were South, North and West Gates but no East Gate because, as explained in the description of the castle, the land was so steep that storming the town from the east was well-nigh impossible. The North and West Gates were demolished in Victorian times but the South Gate (now usually referred to as Southgate) is in an excellent state of preservation, with traffic passing through it. Before the bypass was constructed, some years ago, the Southgate caused many problems when big vehicles tried to get through it, but now all heavy lorries, coaches etc. can use the bypass and have no need to go through the Southgate.

It differs little from its original appearance, although a pedestrian thoroughfare was constructed during Victorian times. But climb the steep stone steps and open the heavy original door and you are in another world. One of modern technology, in fact, because the building now houses a photographic studio. In the past it has also served as a small museum and much later an art gallery. It is a very far cry from the days when it was a prison, and a noisome one at that; dark, cold and cheerless and totally lacking in any amenities and thus it had served since the fourteenth century.

Until 1884 the Southgate deserved its reputation and the name by which it was known – the Dark House. As far back as 1381 it was notorious and there are records to show that two keepers were employed to guard prisoners incarcerated within. In 1850 it was described as 'a most filthy and dilapidated place'. In some of the rooms the doors were only four feet high and fifteen inches wide, which must have caused awful problems for tall and burly men. The upper floor was used as a debtors' prison and the lower floor housed petty offenders, and was known as the felons' prison. It is no wonder it was dark, as the only daylight came from an aperture 3 feet by 9 inches and almost totally obscured by iron bars. People imprisoned there must have thought they were in a living hell and would lose all hope of freedom ever coming their way again. Such conditions cannot even be imagined today.

There was a fireplace in the Southgate but no fuel was provided and overcrowding was a constant problem. The petty offenders' accommodation was supposed to house twenty-five people at any one time, which was more than crowded enough, but in 1827 it was recorded that five burglars were sleeping in one bed, while others presumably had to sleep on the floor. The prison was finally closed in 1884 and in 1886 the Launceston Historical Society converted it into a museum and made it far more appealing. It was used for that purpose for a number of years with some bizarre exhibits that would have no place in any museum today! One such exhibit was a burnt black loaf of bread, reputed to be a survivor of the Great Fire of London. How it came to be in Cornwall no one will ever know! The heavy old door to the Southgate is supposed to have been the entrance door to the 'condemned cell' of the old prison in the castle grounds.

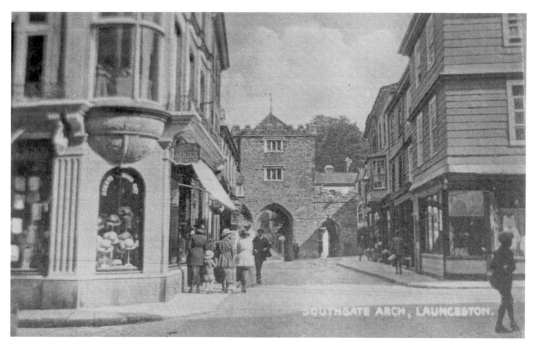

This photograph shows Southgate as it was in the Edwardian period. It was here in 1758 that Philip Gidley King, arguably Launceston's most famous son, was born to a draper and his wife. At the age of twelve he joined the navy, and was later promoted to lieutenant. King sailed as part of what is known as the 'First Fleet' to Australia and founded the convict settlement on Norfolk Island. Later he became the third Governor of Australia. At one period Treleaven's was 'the' fashionable ladies' and gentlemen's outfitters' in town. The business closed in the 1970s, but the name lives on in Treleaven's Corner. Further along is the King's Arms, known as the Baker's Arms since 1989. The slated building on the right of the picture has variously been Parker's shoe shop, Simon Claire ladies' outfitters' and, currently, the Oxfam charity shop. Nearer the arch was Ching's store and wine vault and the doctors' surgery was in the corner by the pedestrian arch.

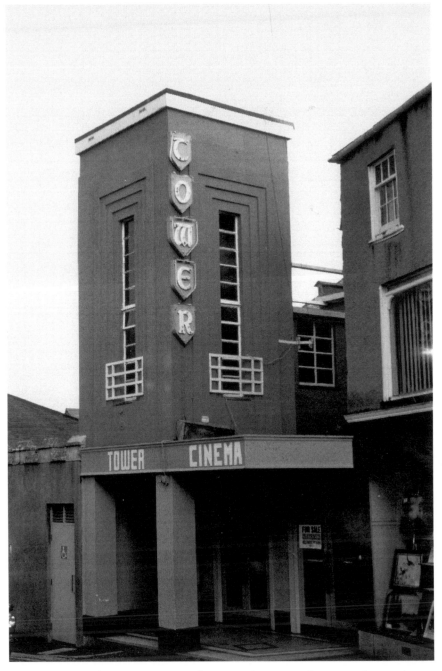

From its opening date in August 1935 the Tower cinema was the centre of entertainment in Launceston. At the time it was described as being the most modern in either Devon or Cornwall. The first film screened was *D'Ye Ken John Peel* starring Leslie Perrin, Winifred Shotter and Stanley Holloway. At one time the screening changed on Sunday, Monday and Thursday, making three different programmes every week. In the 1980s attendance dwindled and the Tower screenings ended in March 1983. Today Market Court, a modern block of flats, occupies the site. (Photograph: John Neale collection)

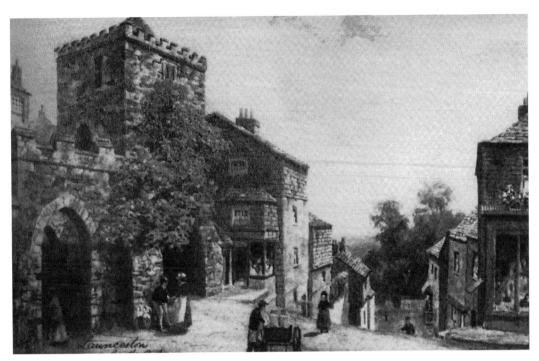

A painting of the Southgate, by the popular artist Wimbush, 1908. The painting was later reproduced in a series of postcards by Raphael Tuck. This picture shows the Southgate Arch and the famous sycamore tree that grew out of the masonry. In 1952 it was thought to be damaging the structure and amid public furore it was felled by council workmen. Also shown is the top of Angel Hill.

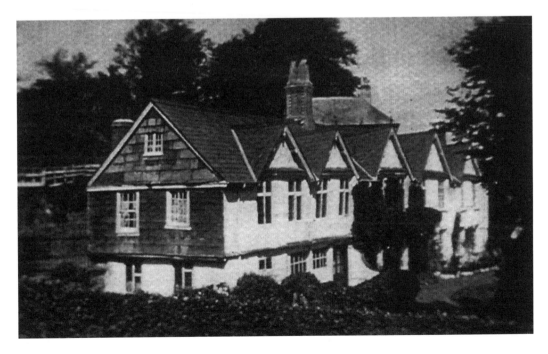

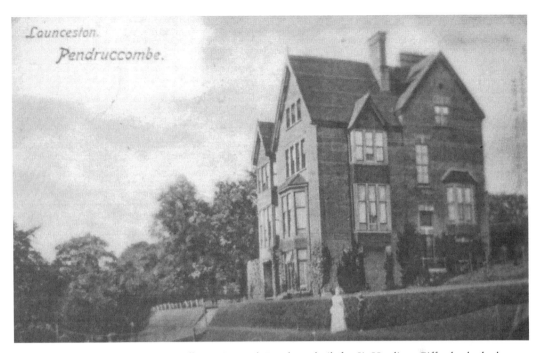

Pendruccombe, the imposing villa on Tavistock Road was built for Sir Hardinge Gifford, who had been elected MP a few years previously. He was later to become the Earl of Halsbury and held high parliamentary office. The villa was built by a local man Mr W. Burt. In the autumn of 1898 the Misses Smith moved their school, which had previously been at Dockacre, to Pendruccombe. During its time, Pendruccombe was one of the main academic institutions in Launceston. Some of its pupils went on to become doctors, journalists or professional musicians, while others exhibited their work at the Royal Academy. Even today old girls are still proud of the brown and cream uniform. After the school closed, Pendruccombe became a private residence for a time. Today it is a nursing and residential home. Some of the garden has been developed. The school tennis courts, some distance away, vanished, along with Monmouth Villa, when the bypass was built.

Opposite below: The town also has several grand old houses of note that were once home to the great and the good of Launceston. Sixteenth-century Dockacre House as it was in 1934. It is one of the oldest buildings in the town and is to be found not far from Southgate arch. It is reputed to be haunted by the ghost of Nicholas Herle, a former Mayor of Launceston and High Sheriff of Cornwall. In 1998 the eighteenth-century roofing slates needed urgent repair and a £40,000 appeal was launched. Every owner of Dockacre House has added a walking stick to the bundle kept in the attic. That added by Nicholas Herle incorporates a flute. Legend has it that anyone who hears the flute's plaintive notes will soon suffer a death in their family.

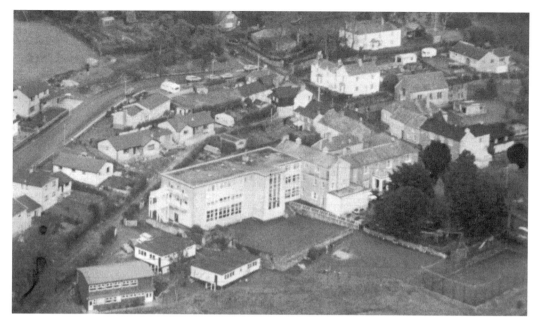

An aerial view of St Joseph's School and grounds. It was formerly a convent and before that it was Newport House, the home of Sir Jonathan Philips.

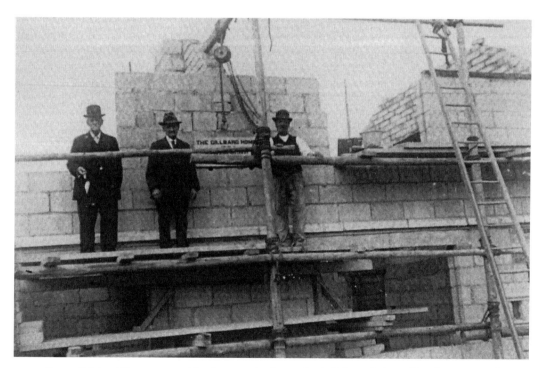

On a slightly different note, this photograph shows the building of the Gillbard Homes and Centenary Flats in 1936. Mr G. H. Gillbard is shown, left, holding the silver trowel with which he laid the foundation stone. He was a remarkable benefactor to the town between 1928 and 1937.

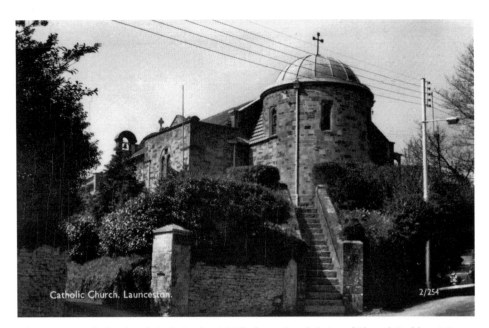

Catholic Church, Launceston.

2/254

The Roman Catholic church in St Stephen's Hill, the national shrine of Blessed Cuthbert Mayne, was opened in November 1911. The Pontifical High Mass was celebrated by the Right Reverend John Keily, Bishop of Plymouth. The church dedication changed to St Cuthbert Mayne on Easter Sunday 1977. At one time, a familiar landmark in St Stephen's Hill was the cross shining out across the valley and over the town from the presbytery of the church. During the war years it was taken down and re-sited near the entrance to the church. Eventually it was replaced in its former position, until a severe storm left the cross literally hanging by a thread and it had to be removed for safety. The idea that it should be replaced came from a former priest at St Stephen's Hill, Father Peter Webb. The project was taken on board by the Catholic Women's Guild, which decided to provide a new cross at a cost of around £360. In July 1984 there was a short service at which Father Matthew McGauran blessed the cross. Mrs Dinner flung the switch and the cross shone out again. Among those present were Mrs Cynthia Buckingham, Mayor of Launceston, several of the workmen from the project, together with their families, and parish members. Sadly, the comforting landmark has been in darkness for some years. (Photograph: John Neale collection)

When it comes to buildings, the glories of the town are its three churches. Each of the churches is different and has a unique history.

St Mary Magdalene in the town centre is a gem, having the finest carved granite exterior of any church in the British Isles and it is a matter of great concern now that the hard granite is fast deteriorating, and in some cases being almost obliterated by air pollution.

The story has it that landowner Henry Trecarrell planned to have built a handsome house for himself and the stone was being prepared for this. Many symbols of Cornwall were to be incorporated in the decoration as well as personal tributes to Trecarrell and his family and religious references.

But before the house was begun, disaster struck. Henry Trecarrell's daughter was seduced by a member of the Kelly family of Kelly, near Lifton, when she was on her way home from church, with the result that she bore him a son. A legend has it that Trecarrell was distraught when his infant son was drowned in bath water while being bathed by a nursemaid, but records in the Bishop's Library at Lambeth Palace show that Trecarrell had only daughters and it is hypothesised that the infant drowned was actually the illegitimate son of his daughter and that Trecarrell was so ashamed of the disgrace brought on his family that instead of building himself a grand house he built a church by way of penitence, using all the elaborately carved stone for the purpose.

The emblems carved in the granite exterior include the Prince of Wales' feathers honouring the Duke of Cornwall, the St Mary's Minstrels (who provided music in the church before the days of church organs etc.) together with their instruments, various plants mentioned in the Bible and even carved portraits of Henry Trecarrell himself and his wife. At eye level, pious words in Latin are engraved, almost encircling the church.

The interior of the building contains some very interesting features, including an elaborate cenotaph commemorating two men who were close friends, which has been the subject of controversy for a great many years. The real truth will probably never be known, though there have been many attempts to decipher the imagery of the monument, with varying conclusions drawn. Incidentally, neither of the men is buried here, so the memorial is a cenotaph and not a tomb.

The present church is the third one on this site dedicated to St Mary Magdalene; the tower was formerly that of one of those churches, the one built by Edward the Black Prince in 1380. The tower is separated from the present church by the vestry, originally the site of cottages and later transformed into a municipal building that was eventually demolished to make way for the present vestry.

Further details of special features of interest in the church are contained in a leaflet on sale inside the main door.

St Mary Magdalene Church Choir in 1900. Ladies and children predominated. They follow in the footsteps of the St Mary's Minstrels, whose emblems can be seen carved on the granite exterior of the church.

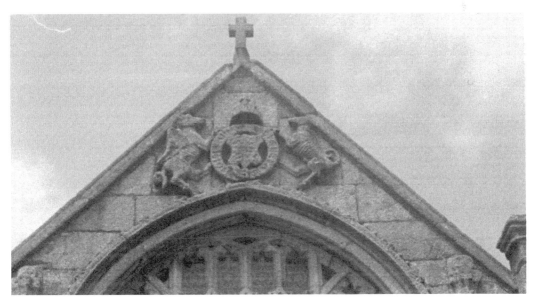

Sir Henry Trecarrell was a staunch royalist and as a display of his allegiance he had the royal arms of King Henry VIII, the supporters of which are a lion and a dragon, carved high on the eastern gable of the church. King James I substituted the unicorn into the Royal Arms in 1603.

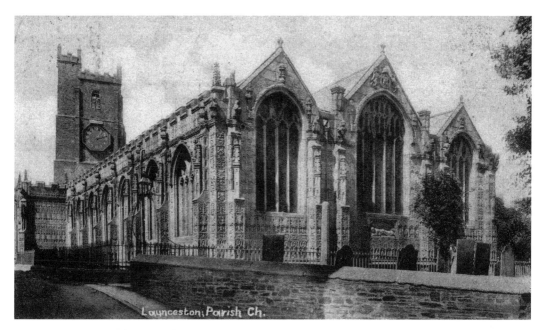

St Mary Magdalene church as it was in 1904. The tower dates from the time of the Black Prince and the clock is the first public clock in Cornwall. Interestingly the dials have, depending on which face you look at, either plain or Roman numerals. The recumbent figure of Mary Magdalene and the St Mary's Minstrels can just be seen under the central eastern window. The railings around the frontage no longer exist, a casualty of wartime. Sadly the age-old tradition of ringing the nightly curfew bell from St Mary's tower also seems to have lapsed. (Photograph: John Neale collection)

The little St Thomas the Apostle church at Newport is in a pretty setting beside the River Kensey and is of historical importance. The greater part of the building dates from 1482. Viewed from the castle its tower looks tiny, but it is a delightful Norman building. Its main door is reputed to have been on its original hinges for six hundred years and the porch has a Norman tympanum. There is also a Norman font believed to have come from the adjoining Augustinian Priory. It measures twelve feet around and has rather menacing looking faces at each of the four corners. The church also has a lepers' window at the base of the tower, a small aperture with a heavy iron grille across it at which, it is said, patients from the leper hospital at St Leonards, about one and half miles distant, stood to observe the service taking place as they were not allowed in the building. It is also believed that gifts of bread were left beneath the window for the lepers.

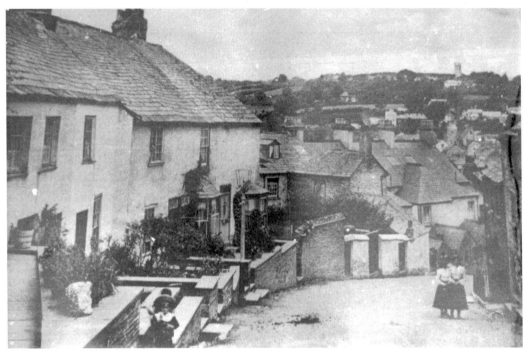

Looking from St Thomas Hill (older residents still fondly call it Old Hill) toward St Stephen's and the church on the horizon. In the days before there was so much traffic, after a fall of snow youngsters used to delight in sledging down the hill on metal trays and crashing into the railway bridge at the bottom.

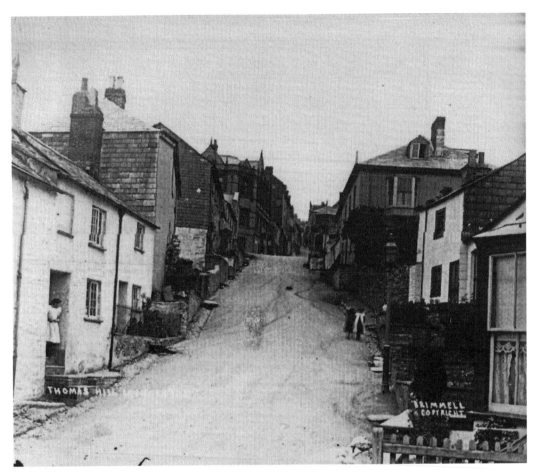

St Thomas Hill in 1910. It has hardly changed since then, except that the road has now been tarmacked and has pavements, and cars are usually parked on both sides. Looking up St Thomas, or Old Hill as it is more generally known. Glimpsed at the top is the old Passmore Edwards library and, at the very top of Northgate Street, the tower of St Mary Magdalene church. Who today, I wonder, remembers buying sweets from Mrs Tink in her shop at the top of Old Hill?

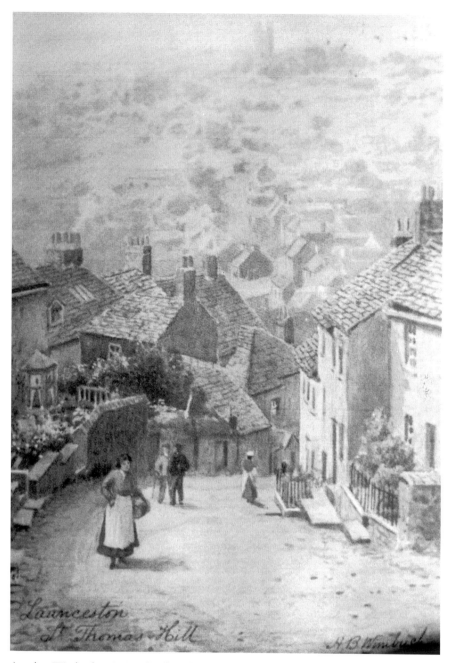

Another Wimbush painting that later became a Tuck postcard.

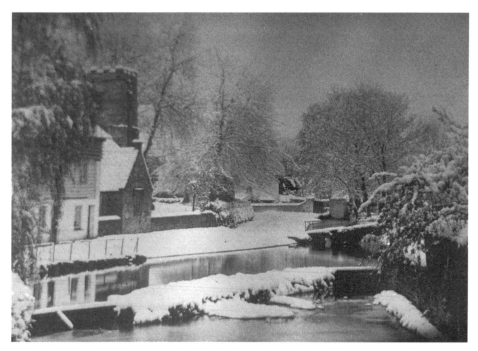

St Thomas the Apostle church and riverside take on an alpine appearance under a thick blanket of snow, in the 1900s. The small building immediately joining the church was once Reed's tannery and later Moore's builders' store. The building was torn down in the 1970s and St Thomas' Church Hall now occupies the site.

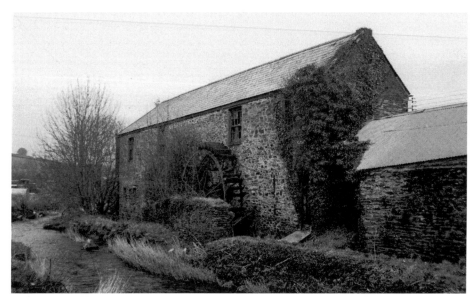

Part of the old Hender tannery complex beside the River Kensey at Newport. The mill race and the waterwheel vanished in a flood prevention scheme in the 1980s. (Photograph: John Neale collection)

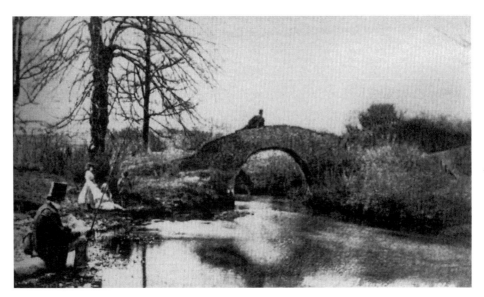

St Leonards Bridge in 1860. Nearby was the site of a leper colony. The bridge itself is medieval. Adjoining St Thomas church are the remains of the great Augustinian priory, founded in 1126 by the Bishop of Exeter as a house of Augustinian canons. By the time of the dissolution of the monasteries in 1539 it was the wealthiest monastery in Cornwall. The nearby Prior's Bridge over the Kensey was the access to the world outside the monastery's walls. After the dissolution the monastery fell into total disrepair and for many years was just a jumble of ruins from which local people purloined stones for building etc.

At one time the ford at St Leonard's, just before the River Kensey joins the River Tamar, was a favourite place for motorists to wash their vehicles. Today the ford has vanished and a 'new' bridge a little downstream spans the Kensey. (Photograph: John Neale collection)

During the construction of the railway and then the siting of gasholders in the late nineteenth century the priory was rediscovered and partially excavated. But it again became neglected and was seriously vandalised, and it was not until 2008 that extensive and important conservation work was undertaken on it by North Cornwall District Council, the Environment Service, local volunteers and other organisations with a grant from the Heritage Lottery Fund. Many features were identified and the site is now protected and kept in good order. A lot of the carved stones littering the site were re-located as near as possible to their original positions after research by County Council archaeologists.

The Norman doorway of the White Hart Hotel is believed to have come originally from the Augustinian priory at Newport.

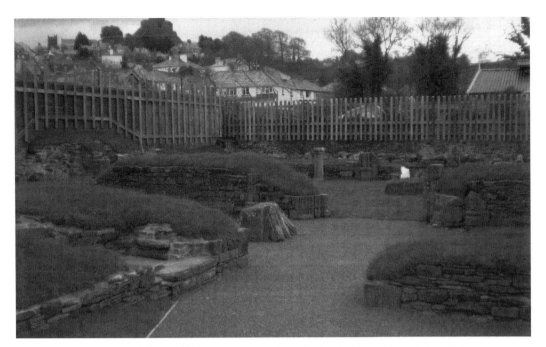

In 2001 the fate of the twelfth-century priory hung in the balance. An archaeological survey was commissioned by English Heritage from the Cornwall Archaeological Unit, now Cornwall Historic Environment Services. It was the first in-depth survey of the site since that undertaken by Launceston solicitor Mr O. B. Peter in 1892.

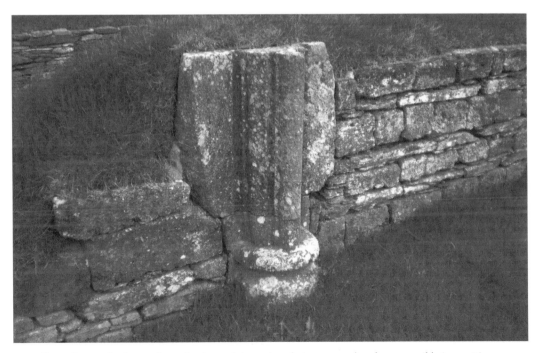

Some fronts of columns from the Augustinian priory being restored as far as possible in 2008/09.

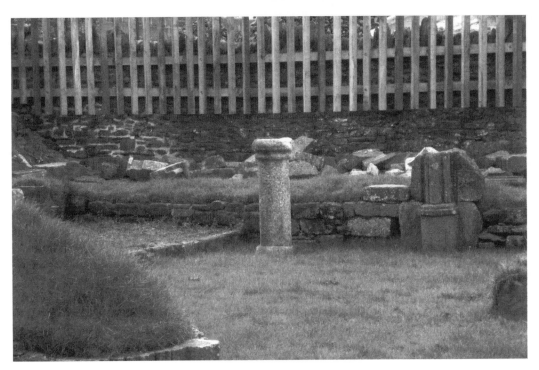

Restoration work on the priory in 2009. The priory was founded in 1126 by William De Warlewast, Bishop of Exeter and was run by an Augustinian Order of Black Canons. In the sixteenth century the priory was one of the wealthiest foundations in the south west. The foundation was suppressed in 1539, after which time the townsfolk used the stone as a free quarry. The site became a dumping ground and remained little known until 1886, when the railway line from Exeter to Padstow was being cut and more of the hidden priory remains were revealed. Local legend has it that if all the stone pilfered from the priory were suddenly to be returned, half of the town would fall down! In 1976 the priory ruins, which were sadly neglected and overgrown, were cleaned up by members of St Thomas' church youth club, after which the altar walls were in much better order. Shortly afterwards, a service, the first in over 400 years, was held on the site. In 2001 the first candlemas service for almost 500 years was held, attended by over 200 people. In 2009 further restoration work was carried out on the site.

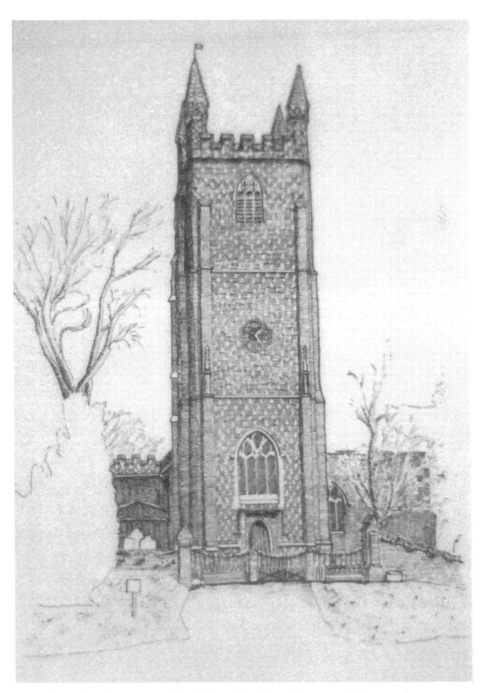

St Stephen's church was originally built in the thirteenth century. However, the tower was demolished and rebuilt in the sixteenth century. It now houses a ring of six bells. In August 1990 the clock face was redecorated with gold leaf by Dawson's, the Bristol-based steeplejacks. Gale force winds caused considerable damage to the clock mechanism in 2002.

When the author was young, the River Kensey was teeming with trout and children would wriggle between the railings on the Prior's Bridge and fish for trout using a piece of string and a bent pin. Their success rate was not very good but it was harmless good fun for them and the trout seemed to be pretty wary about what was going on!

The town's third church, dedicated to St Stephen, is on the north side of the town on a very ancient site. It is from St Stephen's that the town acquired the name Launceston (from the Cornish *Lannstefan*) in place of its old title of Dunheved. St Stephen's, as we now know the area, was the site of a college of secular canons in Saxon days. The church of St Stephen was rebuilt in 1259 and dedicated by Bishop Bronscombe. It was restored in 1855/56. The canons of St Stephen's even built a mint as part of their priory and to this day Mint Field is still so named. Historians claim that it was the only place in Cornwall to have a mint and its coinage circulated throughout the country.

The church of St Stephen has some even older relics, dating back millions of years! This hidden feature was discovered only a few years ago. The author was sitting in the porch, having arrived early for a funeral that was to take place in the church. The heavy coir mat covering the slate flooring had been rolled back to enable the slate to be swept and it was exciting to instantly recognise imprints of fossils in the slate. Not any old fossils either but those of long-extinct fish and a newt-like creature. No one knows where the slate came from. The fossils are not any of the types found in Cornwall and it is assumed that the huge slate flagstone was brought in from somewhere 'up country' when the church was refurbished in the eighteenth century. It is certainly something quite remarkable and well worthy of preservation.

St Stephens also has a holy well; it has always been known as a holy well but why it is 'holy' has never been explained. It was originally an insignificant feature in the hedge. It is thought to date from the mid-thirteenth century, possibly being part of the priory at Newport. In medieval times holy wells were a part of a religious sub-culture and were rarely recorded. The well is in a pleasant lane that leads to a farm. It is sited by Gallows Hill, which has a rather grizzly connection; a gallows was sited there and in days gone by there have been reports of hauntings in the area. Many older people still avoid walking near Gallows Hill, but the author has never witnessed anything supernatural here – perhaps negotiating the extremely stony path deters the ghosts from putting in an appearance?

The well as it now stands is a nineteenth-century structure. The little building over the well was erected by the 6th Duke of Northumberland when he owned Werrington Park. A small underground reservoir was then constructed to supply water to the village of St Stephens at the Duke's expense. It was a simple, rectangular structure built and roofed with slate slabs. A rough metal grille protected the opening. In 1998 the Cornwall County Council Archaeological Unit undertook conservation work on the well and reservoir, replacing the roof and providing a new sturdy wooden door to the reservoir. The water in the reservoir can still be seen through this slatted door. The lane where the well is situated is a public footpath, so it is possible to visit and photograph it.

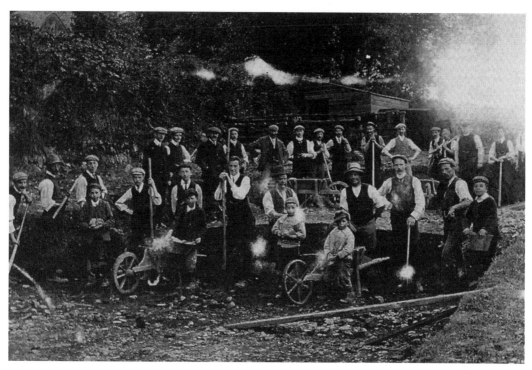

The construction of St Stephen's church hall, in the early 1900s.

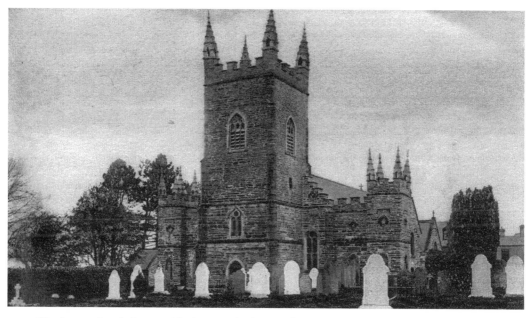

Werrington church, just outside the town, is also worth a visit. It is unique; either side of the main tower are smaller twin towers that replicate it.

Launceston has a lot for which to thank the sixth Duke of Northumberland; he did a great deal for the town. Without him we should probably not have the attractive little Round House at Newport.

The very site on which it stands is historically important; from 1529 to 1831 it was the location at which two Members of Parliament for Newport were declared and their election celebrated. The Duke was a good benefactor to the town, credited with having the castle grounds laid out, transforming them from a disagreeable jumble of pigsties and general disorder, not respected by anyone, to the pleasant recreation grounds we know today. The design for the Round House at Newport is believed to be based on the famous Temple of the Winds in Athens but because of its political connections it was dubbed 'Newport Town Hall'. The Duke was keenly interested in classical works of art and so it is not surprising that he was inspired to build the Round House to such a design.

The Round House was actually built to house the broken shaft of the Newport Cross. In his book *Stone Crosses in North Cornwall* Andrew Langdon describes it as one of the few examples of a market cross in Cornwall. He explains that in many English villages the market cross was the focal point of the village; market stalls were set up, proclamations were read out, punishments delivered and deals agreed, all at the cross. The Newport Cross has a massive granite base and one assumes that the height of the cross would have been in proportion to that, although only the octagonal stump of the shaft remains.

Over the years the Round House building was vandalised and became extremely shabby, no longer was it a desirable place to rest for a short while. But, in 2005, a full restoration was completed, including high grilles to block entrance to it, and a bronze plaque fastened to it that gives details of its history.

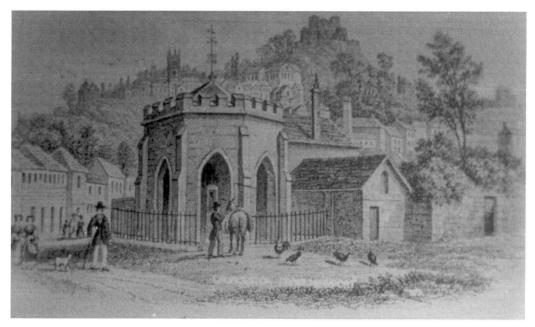

The Round House in Newport Square was built in 1829.

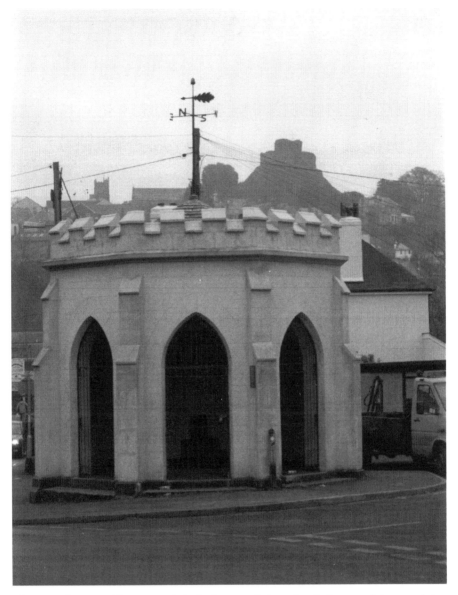

The Roundhouse at Newport as it looks in 2012. It is an iconic feature of the area, being one of the 'stations' in the town from which royal proclamations, such as new monarchs, royal births or jubilee celebrations, are announced by the mayor and Corporation. In 1923 it was given seating and a cement floor. In 2005, over a five-month period and at the cost of some £3,000, the building was restored, with new leaded guttering and repairs made to the battlements slates, roof timbers and the weathervane. Over the years, many a friendship has taken a more serious turn and romance has been kindled in the Roundhouse. (Photograph: John Neale collection)

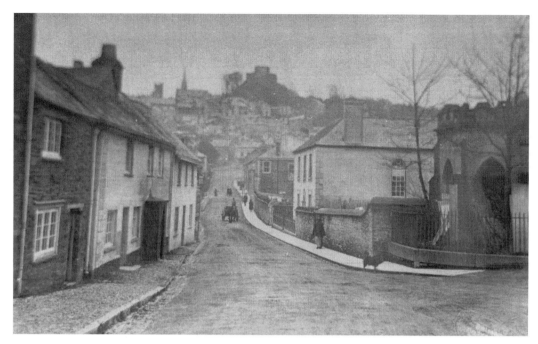

In comparatively recent years the Round House was the site of the proclamation of a new monarch ascending to the throne and a focus of jubilee celebrations; no doubt it will be part of similar national events in the future. The building is Grade II listed and its restoration was commissioned by Launceston Town Council at a cost of approximately £30,000. Its name of the Round House (even though it is not round!) has been in existence for many, many years.

At one time the solid and well-built Jubilee swimming baths in Underlane were a popular venue for sporty types. One part was known as the grandstand, where spectators could watch the aquatic capers. The sports day was particularly popular and drew crowds of people. At one period the caretaker acted as instructor to the youngsters. Interestingly, in the 1930s the Jubilee baths had its own unofficial magazine called *The Pelican* and Charles Causley was one of its editors. Some years later, an open-air swimming pool was built at Coronation Park; this has since been superseded by a modern leisure centre complex. (Photograph: John Neale collection)

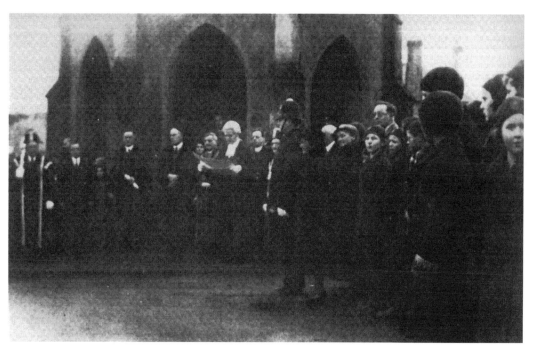

Town Clerk Mr Stuart Peter reads the proclamation of King Edward VIII at Newport, 1935.

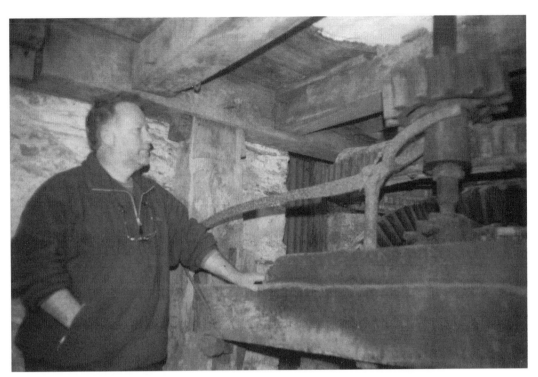

Ridgegrove Mill is one of the oldest watermill sites in Devon and Cornwall, with activity recorded here in the *Domesday Book*. The mills are known to have been used for various production activities, including grain milling, woollen textile production, iron working and grinding bones for fertiliser. In recent years plans were forged to restore the Grade II listed building, but they were never fulfilled. Here we see some of the photographs that were taken of the mill during the planning process. Mr Richard Page surveys the grinding machinery. He hoped to repair Ridgegrove Mill to a working mill or at least to restore it as far as possible, but unfortunately his plans never came to fruition.

Opposite below: This picture shows the toll-house at Town Mills, one of Launceston's several toll-houses, The Launceston Turnpike Trust was formed in 1760 for the purpose of the upkeep of the roads. In November 1879 the *West Briton* newspaper reported that in Launceston the church bells were to be rung at midday to mark the fact the turnpike tolls in the district would cease to exist. In fact this would prove to be a little premature, as the final meeting of the Turnpike Trust did not take place until March the following year. (Photograph: John Neale collection)

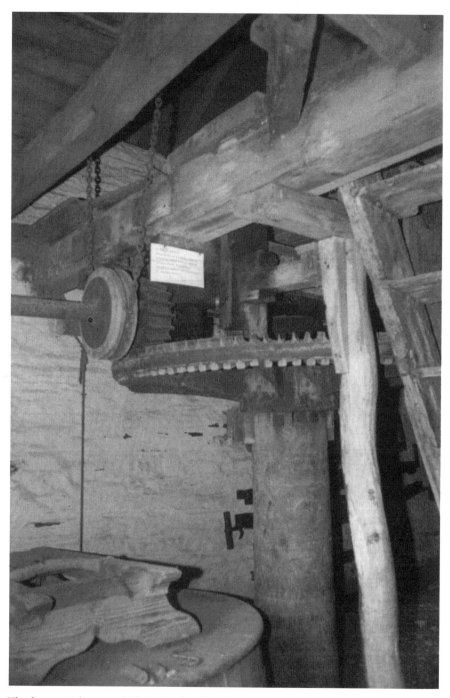

The former Ridgegrove Mill during the plans for restoration.

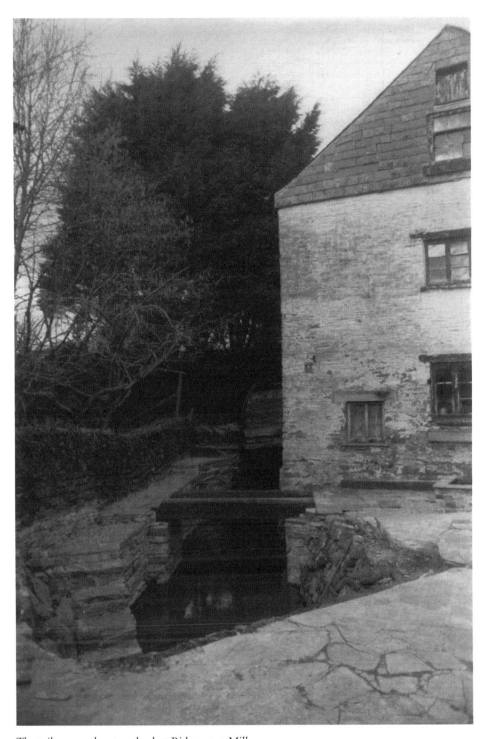

The tail race and waterwheel at Ridgegrove Mill.

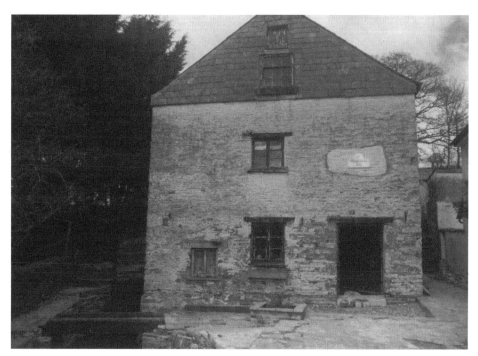

Ridgegrove Mill is mentioned in the *Domesday Book*, where it is noted that rent was paid to the canons of St Stephen's priory until the new priory at St Thomas was built down in the valley. In the early seventeenth century the mill was owned by one Sir Francis Drake, a nephew of the celebrated Elizabethan mariner of the same name. The mill ceased working in the 1940s.

The Glasshouse, Hayman's photographic studio, in the late nineteenth century.

An inconspicuous little building, largely overlooked in the story of notable aspects of the town has in a sense made a contribution to shaping history. The building at the corner of High Street and Church Street housed tearooms for a number of years, in fact, it is still known locally as 'The Orange Tea Rooms'. Later, a florist's shop occupied the ground floor for many years, the upper floors being a residential flat. However, In Victorian days many people flocked there for what was then a very novel purpose – to have their photograph taken! No one then could envisage the popularity of photography today.

At one time this corner building was the premises of a pioneer in the art of photography, one Henry Hayman. Mr Hayman and his son were general dealers; they ran what is known in Cornwall as a 'tiddley shop' – that is, they sold just about anything and everything from groceries to small items of ironmongery and often local fruit and vegetables when in season. But the Haymans were not just small traders. They were at the cutting edge of technology in those days, because Henry set himself up as a portrait photographer.

When the author's grandfather was a young man, he was apprenticed to a chemist, Mr William Wise. He had a shop a few doors away in the High Street where he took apprentices for the beginning of their training as doctors. Grandfather Culley was one of the first customers to have his picture taken by Henry Hayman. Frederick Culley introduced Emma Tingcombe, his fiancée, to Henry Hayman. Emma herself was something of a novelty, being the first woman from the town to be employed as a hotel receptionist at the White Hart Hotel – this was a time when young ladies were not really expected to take employment. She in turn recommended Hayman's photographer's to the customers of the hotel.

The Haymans prospered, and in 1880 they opened Hayman's Pianoforte Warehouse, selling pianos, music and possibly other musical instruments. The premises have a most impressive façade; the name Hayman is still to be seen above the present shops on the site.

Henry Hayman called his photographic studio the Glasshouse and he installed iron railings around the large window that supplied good light for photography. We are told there were vandals about even in those days and a large expanse of glass must have seemed a very attractive target, hence the railings.

This historic and interesting building was under threat of demolition in order to ease traffic flow but has since been reprieved. It is certainly hoped that its historical significance will be fully recognised and that it will remain a feature of the town centre.

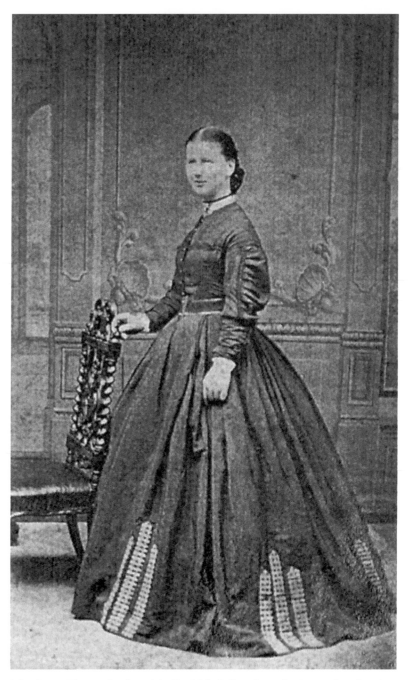

Miss Emma Tingcombe, later Mrs Fredrick Culley, the author's grandmother. As a young woman, shown here, she was the first woman to hold an executive position at the White Hart Hotel in the Square. How times change! In 2011, the White Hart has recently changed hands, and the long-standing manageress and two of the new directors are ladies.

Looking down onto Launceston Square and the war memorial, when cars held sway, pedestrianisation was just a dream and the cobbles had yet to appear. (Photograph: John Neale collection)

The Sherriff Stone is now in the castle grounds but it is believed to have stood beneath the gallows in the square. Prisoners would have stood upon it prior to the rope being lowered, hanging them.

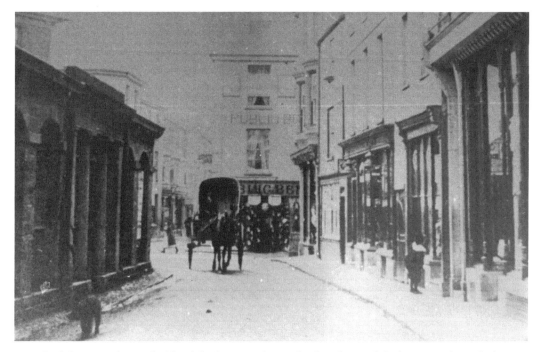

Back Lane, on the south side of the Square, prior to the demolition of the butter market, which is seen on the left. This area is now all part of the pedestrianised Square.

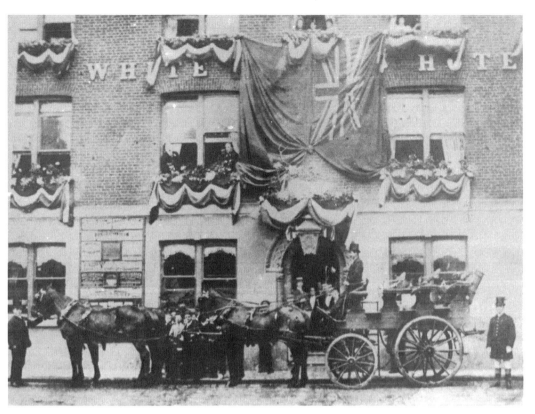

The White Hart Hotel is decorated for some royal occasion, possibly Queen Victoria's jubilee.

Looking from Broad Street to the Butter Market in the nineteenth century.

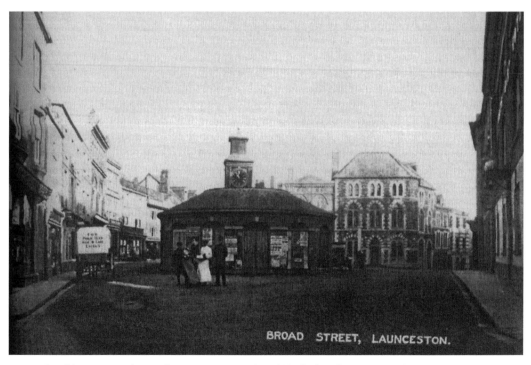

BROAD STREET, LAUNCESTON.

The old Butter Market in the square. It was demolished after the First World War to make way for the war memorial.

The Square is at the very heart of Launceston, and it has seen many changes and acted as a focal point for the life of the town. The war memorial is a particularly notable feature of the square, serving as it does to remind us all of the sacrifice that Launcestonians have made for their country.

The war memorial commemoration stone was laid by HRH Edward, Prince of Wales and Duke of Cornwall on 25 May 1921. The granite memorial is engraved with the names of eighty-six Launcestonians who were killed or missing in the First World War. A further thirty-four names were added after the Second World War.

The memorial text reads: 'To the immortal honour of those from this town who gave their lives for King & Country in the Great Wars 1914–1918, 1939–1945.' A remembrance service takes place at the memorial every November. The impressive memorial now rightly has pride of place in the centre of the town square. It stands thirty-six feet tall and takes the form of a medieval town cross. It is raised on a stepped base, and the solid portion has panels on three sides carrying the names of the fallen in gold lettering. Above the solid part there is a tracery of celtic crosses with shields displaying the arms of Launceston, the Prince of Wales' Feathers and the arms of Cornwall. The building was undertaken by the Bodmin Granite Company.

The dedication service was conducted by Revd Tippett Rivers and the Mayor's chaplain Revd Shepherd Gibbs, along with representatives of other religious denominations. The unveiling ceremony was performed by Mr J. C. Williams, Lord Lieutenant of Cornwall. Other dignitaries included Mr J. Treleaven, Mayor; Mr C. H. Peter, Town Clerk and Mr George Croydon Marks MP. Also prominent were the relatives of the fallen. By all accounts there was a vast crowd to witness the scene and onlookers took full advantage of every window and balcony. Contemporary reports record, with some just pride, that the memorial cost £2,000 but that on the day the flag fell from the monument it was debt-free!

The memorial did not always have chains around it, but when a move was made to have them removed in the 1930s it was described by a number of townspeople as a 'disgrace'. In more recent times the same idea was floated under the guise of being an improvement to the townscape. Oppostion to the plan was raised by the Royal British Legion and the Burma Star Association. Fortunately the chains remain today and they prevent people from climbing onto the memorial or eating and drinking on the steps, though there is a polite request that they should not do so.

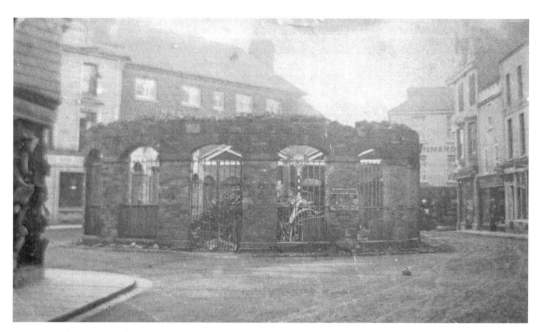

The demolition of the Butter Market.

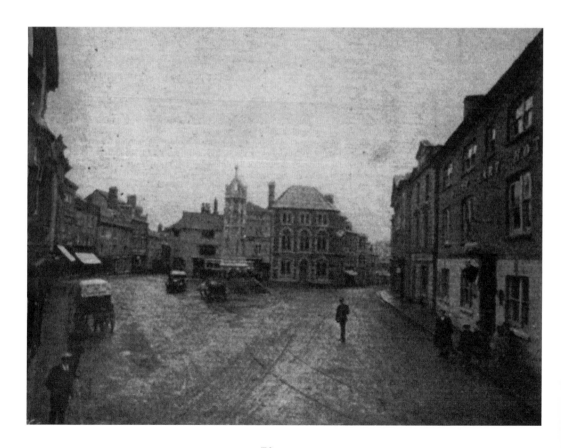

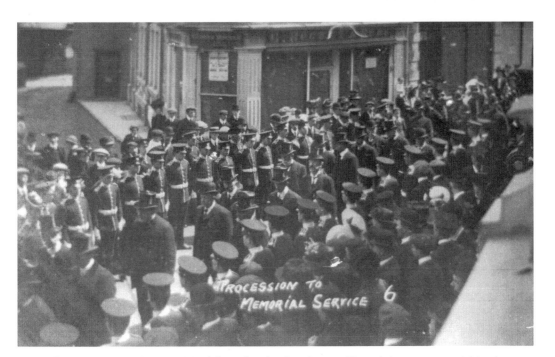

The procession to St Mary Magdalene church after the unveiling of the war memorial in the town square.

Opposite below: Launceston Square and the memorial. Originally the Assize Hall stood on the site, which was demolished to make way for the George Whitwick Upper Market House, or the Butter Market. In 1921 this was in turn torn down and replaced by the war memorial.

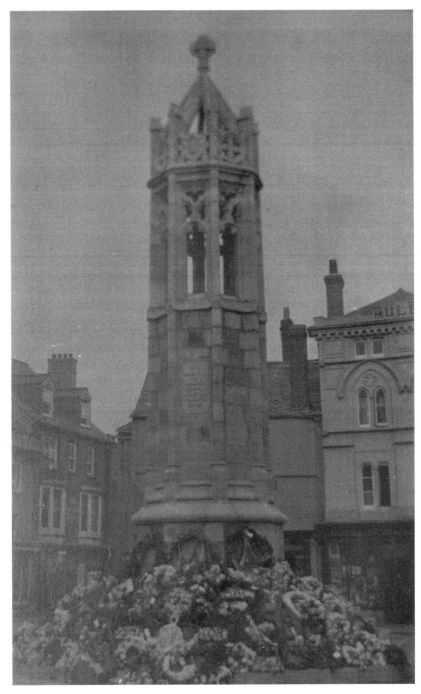

The memorial shortly after its dedication. Just in view, to the left of the memorial, is one of the oldest houses in Launceston, that of Thomas Hicks, one-time Mayor.

You won't see it but beneath your feet when you are in Launceston Square is a remarkable example of Victorian building and ingenuity. Under the war memorial and the pedestrian layout is a reservoir.

It is accessed by steps leading down from a passage next to the Barclay's Bank building. The water it holds is crystal clear and it always finds its own level, never overflows and never runs dry. The chamber itself is handsome; it is of a brick-lined, dome construction and has a walkway around it. It has been likened to a miniature cathedral and demonstrates Victorian craftsmanship and workmanship at its best.

Launceston had a long history of problems with water supplies in the past; this reservoir is supplied by piping from various sources and is largely maintained by the local fire service. In the event of fire at premises in the town centre the fire brigade pumps water from the reservoir under the Square. It has on numerous occasions proved to be invaluable

As a postscript to this, a relic of Launceston's past water supply can be seen at street level on the side of the Southgate. There can be seen granite stone with a hole in the middle; the hole originally held a tap, the first public water supply to the town in 1826. The initials P.C.H. are carved into the stone, in reference to Parr Cunningham Hockin, mayor of the town at the time. It is a most interesting feature, probably unique.

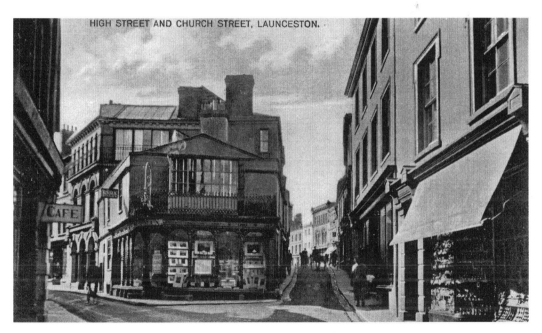

This image shows the junction of Church Street and High Street and the building still fondly called 'The Orange Tea Rooms', a business which once occupied these premises. In more recent years it has been used for various business purposes, notably as a flower shop. Recent research has revealed that it was once Henry Hayman's photographic studio. This 'conservatory' is believed to be the only Victorian photographic studio of its type in the country, but in 2007 the building was threatened with demolition. Thankfully this recently discovered gem of Launceston history was saved and has since been restored. (Photograph: John Neale collection)

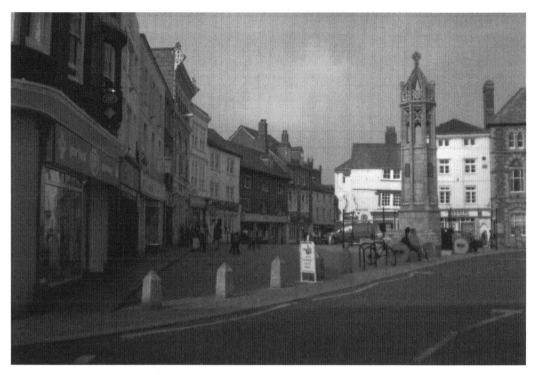

A modern photograph of the war memorial in the recently pedestrianised Launceston Square.

2

Town & People

Those taking part in 'Beating the Bounds', sometime in the early 1930s, enjoy a refreshment stop. Beating the bounds is an ancient custom that was once carried out in most English parishes. The boundaries of the parish were ritually marked by beating the trees, walls and hedges that marked them with willow sticks, or by beating young boys (although often only symbolically) at each location.

'Launceston is a small market town' – an early writer's description. It not quite so small now since the developers moved in, as they have in most Cornish towns. Nor is it really a market town any longer. The busy cattle and pannier markets that drew people for miles around have now both gone and the scene has dramatically changed.

Every Tuesday, market day, the town would be heaving with farmers making their way to the cattle market in Race Hill, while their wives scoured the shops. Cattle and sheep were driven through the town to the market, often walked from long distances and having lairage overnight in fields at Newport and St Stephens. In later years they were conveyed by cattle lorries, which would queue up in Race Hill to get into the cattle market. In this day and age it is more common to see perhaps a couple of dozen people moving around the Square at any one time: the

bulk of the business is more likely to be in the big supermarkets on the outskirts of the town. The crowds and the buzz of market day are gone forever. Prudent housewives would often be in town waiting for the butchers' shops to open at 8 a.m. in a bid to secure the best joints!

In the pannier market the regraters would arrive with their big baskets, covered with spotless white cloths, containing their produce to sell on their stalls in the market. The dictionary definition of 'regrate' is 'to buy up (corn, provisions etc.) to sell again in the same or neighbouring market so as to raise the prices'. This is not exactly what the Cornish know as a regrater, because the sellers would be offering their own produce, grown or reared on their farms or smallholdings and their baskets could contain poultry, eggs, butter, possibly honey, cheese, fruit and vegetables or perhaps flowers from the garden as well as sometimes home cooking in the form of delicious saffron cakes with the strands of real saffron being prominent! In 2008 the Square was pedestrianised (in the face of a lot of local opposition) and on Tuesdays and Saturdays a few market stalls are set up there, but no longer do the regraters come with their tempting foodstuffs and most of the stalls are occupied by market traders from cities such as Plymouth, offering cheap jewellery, children's clothes etc. A farmers' market is held for three hours every Friday morning in St Mary's Church Hall and this is an outlet for local people to sell produce from their gardens, home cooking etc. It is very popular and well-patronised but nothing like the scale of the old pannier market.

The square was once at the centre of the thriving commercial life of Launceston, not just in terms of the market, but also the shops and businesses of all kinds that congregated here and in the surrounding streets.

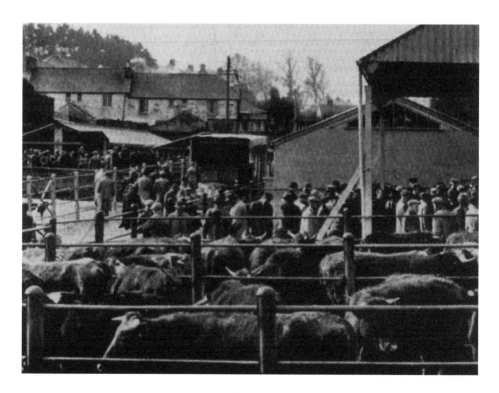

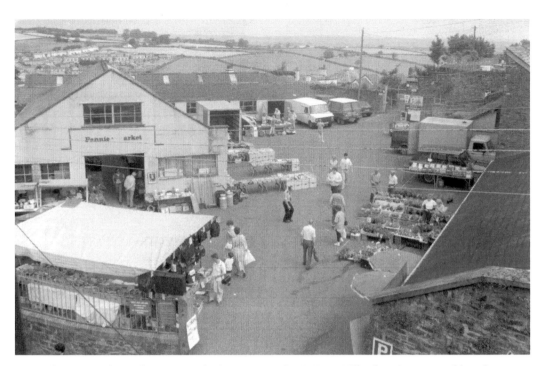

This picture shows the now vanished pannier market in Race Hill, where it was possible to buy clothing, seasonal produce, material, books, antiques and collectables. The indoor market ceased trading in 1994 on the direction of the North Cornwall District Council, as it was felt that the buildings were in need of costly repairs. Outside trading continued for a short time.

Opposite: The cattle market opened in Race Hill in January 1900. Prior to this time cattle were sold in the square. The new market, some three acres in extent, was built on a sloping site in three levels, each one several feet higher than the previous one. The main entrance was from Race Hill with a second exit onto the Exeter Road, which was easier as animals would not have to be driven through the town centre to reach the railway station for transportation. In 1991 lengthy discussion took place considering alternative sites out of town, but none came to fruition. At the time Hallworthy, some miles out of town, was already a thriving market and was the obvious front runner. Suddenly the cattle market was gone and Launceston's days as a real market town with it. The buildings were torn down and it is now a car park. People of the older generations still refer to Tuesday as 'market day'!

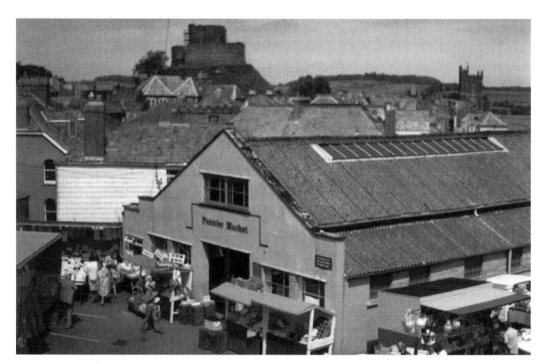

Demolition of the pannier market began in March 1995 against an avalanche of protests from the public and some traders who had been part of the market scene for many years. Some stallholders ceased trading, while others opened small shops, which are thriving despite the current recession, helped no doubt by their loyal customers from their time in the market. The pannier market site is now a car park for the most part, with the occasional stall selling old tools, plants, clothing and fruit and vegetables in season. (Photograph: John Neale collection)

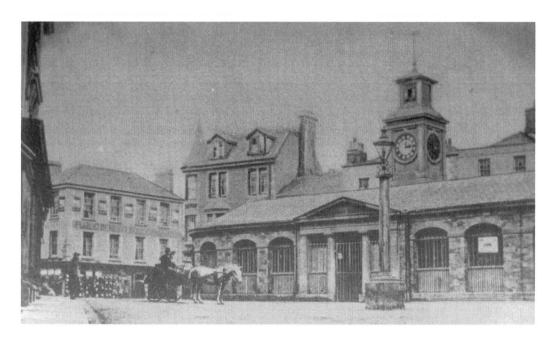

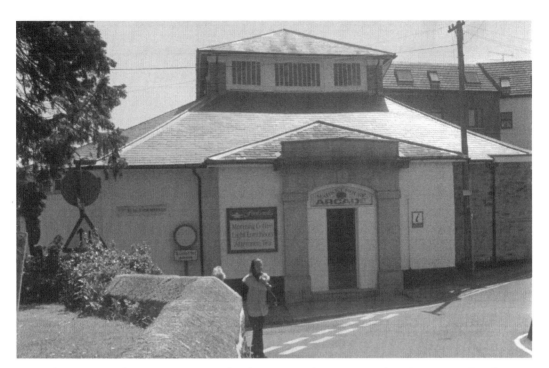

The Lower Market House as it is today. At one time the Lower Market House was primarily occupied by butchers on the top level. On the lower level, accessed by steps from Market Street, was fishmonger Mr Mills. Today it is known as Market House Arcade and is occupied by a hairdressers', tourist information, a café and a health food shop.

Opposite below: The upper market building, later known as the Butter Market, in the Square. It was demolished after the First World War to make way for the war memorial. Some years ago the main portico came up for auction, and luckily it was saved by a local businessman – it now takes pride of place in his garden at home. The well remembered Public Benefit Boot Company shop is just visible. Later it became Lennard's shoe shop, which closed down in 1988 with the loss of several jobs. Later the premises became the Alliance and Leicester Building Society. It is now occupied by another well-known high-street building society and bank.

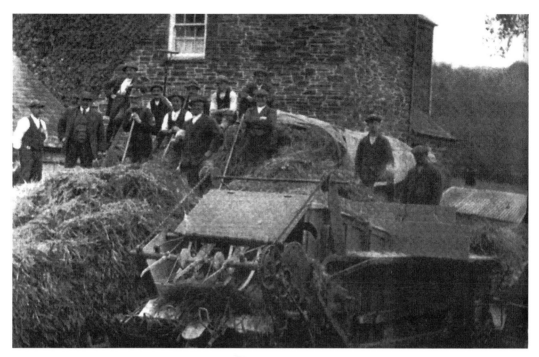

Threshing day at Rockwell Farm, Yeolmbridge, in 1910.

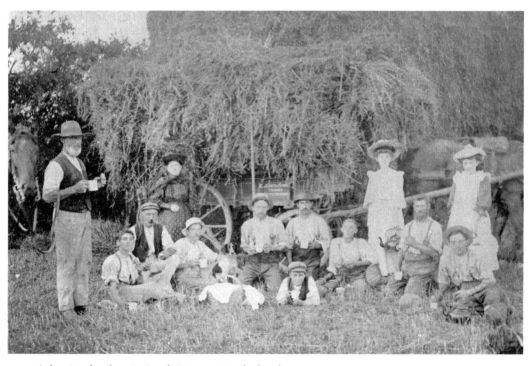

A farming family enjoying their 'croust' in the hay harvest.

Barriball's grocery store in the town always had quite ornate window displays. It was famed for its sausages, which can never be matched today! When the author was living in London and returned to her hometown for holidays the first thing she wanted to taste was always Barriball's sausages! The shop was opened by Mr Daniel Barriball in December 1874. For many years it was the leading grocery shop in Launceston and prided itself on carrying a wide range of goods backed up by good old-fashioned personal customer service, where members of staff were expected to know many of the customers by name! Latterly the shop was run under the watchful eyes of Mr Harold, and Mr Roy Barriball. Sadly the shop closed in January 1970, just short of its centenary year, but is still fondly remembered over a wide area of town and country by those of a certain age.

A special display of Christmas stock at Folley & Reynolds' shop in High Street. The shop was a high class grocery shop and delicatessen, and stocked many grocery items that were unavailable elsewhere. The shop closed down in October 1985. It is probably the shop that is missed in the town more than any other.

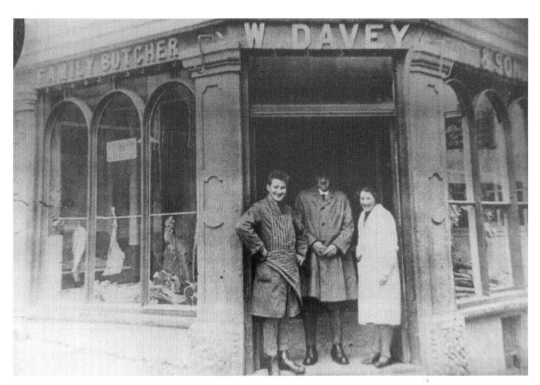

W. Davey & Son, long established butchers in town. Now Phillip Warren & Sons, also butchers.

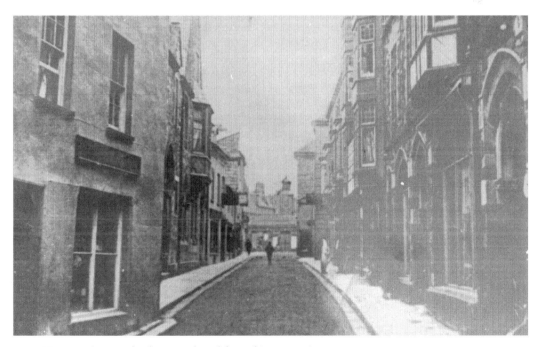

Westgate Street today has not altered from this 1920s view.

Looking down Church Street. Treleaven's was the major draper, outfitter and fashion store in the town for many years up until modern times. The premises are now occupied by a building society. Launceston's famous Treleaven's shop with their distinctive awning. The ladies' and gent's outfitters' shop easily lent its name to the corner on the junction. It was from this vantage point, stationed between the square and the Southgate Arch that Mr Tom Sandercock, the country's earliest and longest-serving traffic warden, deftly orchestrated traffic flow, including buses and lorries, as they progressed in both directions.

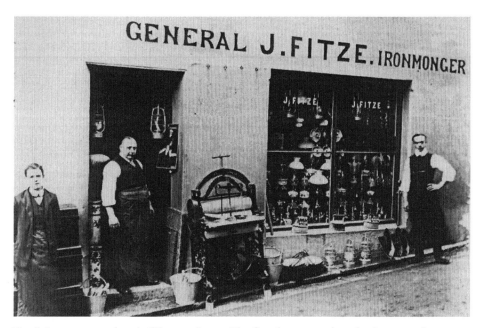

Fitze's ironmongery shop in Westgate Street. The firm later moved to the Square and was run for many years by Mr Sidney Fitze (shown on the right as a young boy) who took over from his father, also Sidney (standing in the doorway).

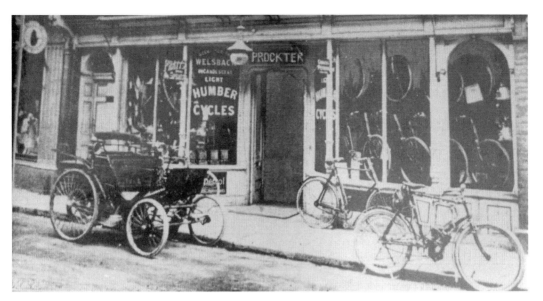

Prockter's cycle shop, prior to the First World War.

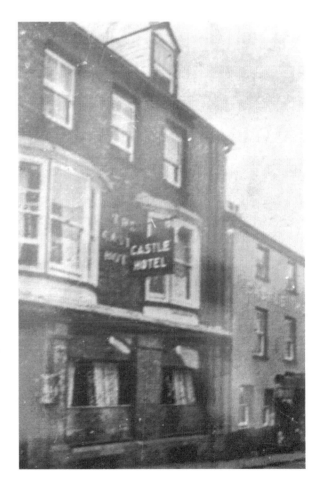

The Castle Hotel in High Street. It closed down many years ago and is now shops with flats and storerooms above.

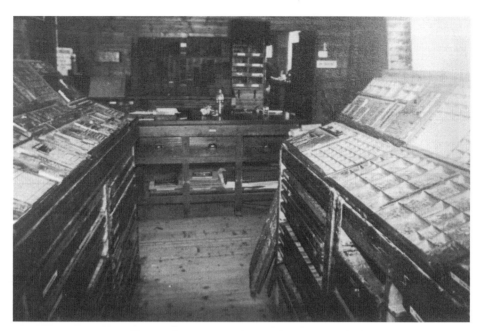

Many Launcestonians will remember going up the wooden stairs (with the 'Ring the Daisy Bell' at the bottom) to the Launceston Printing Co. premises in Race Hill, and seeing type being set up by hand, the letters being plucked at lightning speed from the compartmented wooden trays.

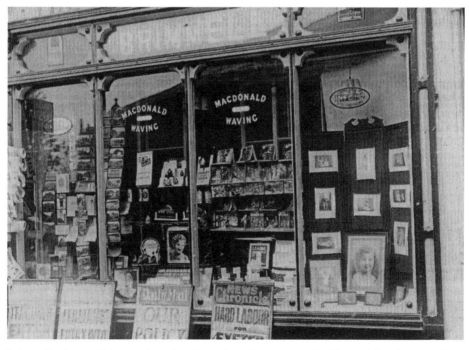

Brimmell's shop, which was also a hairdresser's and a newsagent's. Many of the photographs in this book were taken by Brimmell's. Today it is a bookshop.

Having been born within a short distance of Newport Square it is not surprising that this writer's earliest memories are of that area of Launceston. Newport in the 1920s and '30s was almost a little town on its own; it had every facility for everyday living and its residents could happily survive without having to 'go up the hill to town' very often. There was everything one could possibly need in terms of shops and services in Newport during that period, including a 'tiddley shop' (a Cornish expression) selling almost everything from newspapers and sweets to household items, stationery etc. Newport also had Horwell Girls' School, two railway stations, swimming baths, a bowling green, Hender's tannery, Fulford's corn mill complete with enormous waterwheel, a gasworks, an abattoir and a garage. What more could you want? Earlier the woollen industry had flourished at Newport but it had ceased by the onset of the First World War. There was even a dressmaker who made wedding dresses for many local girls, and Grant's monumental works to cater for the demise of residents.

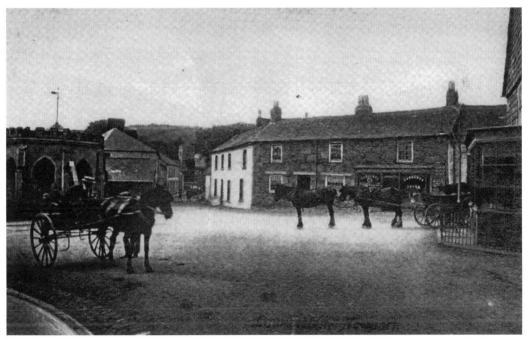

Newport Square in 1911. It has not changed greatly except that there is now a roundabout in the centre. Just glimpsed at the end of Westbridge Road, in this 1911 photograph, is St Thomas the Apostle church. The famous Roundhouse was once used as a builders' stores by Mr George Burt who bequeathed the building to the town. At one time flooding was always a curse at Newport. When the River Kensey broke its banks and flooded into Westbridge Road youngsters used to watch to see if the rising flood water would begin swilling around the Roundhouse. Since the 1980s a flood prevention scheme has been in place so serious flooding is more of a rarity.

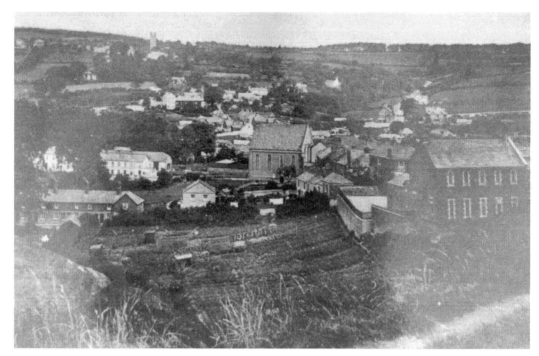

View from Launceston over Newport towards St Stephen's in the 1930s. The Willow Garden allotments are prominent in the foreground. Easily identified is the old National School built in 1840. It is here that Launceston poet Charles Causley attended school as a pupil and then later as a teacher. In 1983, after sitting unoccupied for a decade or so, the building was deemed by some builders to be sliding down the hill. However, in 1985 it became Enterprise Tamar, a complex of units for small businesses. Today it is chiefly a centre for computer studies. Also in the picture is the Association Chapel, which was also built in 1840 with the capacity to seat a congregation of 350 people. It closed in 1946, and the following year it became a factory belonging to the Cornish Brush company. Since then it has been a furniture store, undertaker's parlour and a recording studio. The building was demolished in February 1998. The keen-eyed will notice that Priory Park has yet to be built.

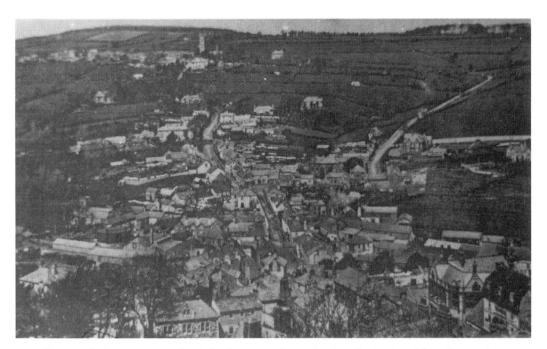

Newport had grown tremendously by the 1940s. Strangely, since the demise of the railway, it has grown beyond all recognition. Almost all of the railway buildings have disappeared and the former site is now an industrial estate, with a supermarket and other businesses. Ironically, there are now more car-orientated businesses on this former railway site than in any other part of town!

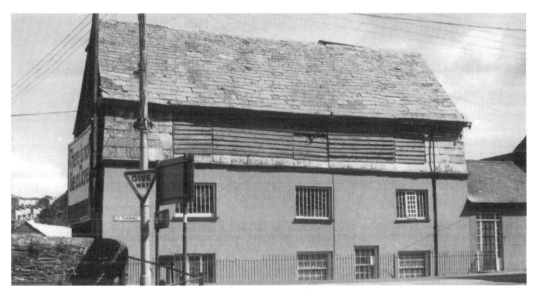

The former Hender's tannery at Newport. The skins were laid out to dry on the top floor, hence the slatted section that allowed the air to circulate. There were several tanneries along the river, which employed many of the people of Launceston. At one time there was a large waterwheel as part of this complex but this, along with the wheelrace, was taken away during a river widening flood-prevention scheme in the 1980s.

Mr Grant built a row of six cottages in the late nineteenth century, which were known as Grant's Cottages until later they were more grandly renamed Winsor Cottages. At the back of the terrace Mr Grant established his monumental works. Up until the time of the Second World War and beyond of his family occupied three of the cottages for many years. The monumental works were behind the first two of the cottages. There Mr Northey, a hard-working and skilled monumental mason, toiled and chipped and carved, preparing gravestones, which always had the inscription 'Grant Lanson' carved at the back and many of which can still be seen in local graveyards. Granite and slate were the usual materials for gravestones in country churchyards at that time and marble was only seen in larger and more modern cemeteries.

Operations at the monumental works were very different from what they are today. There was no machinery or electronic equipment – everything was done by hand and Mr Northey was the kingpin; and one of those lovely old characters who shaped Newport in the 1920s and '30s. When a gravestone was ordered he would push a wheelbarrow up the hill to Barricadoes Quarry at St Stephens to fetch a suitable piece of slate. Having selected his slate it would be loaded on to the wheelbarrow for transporting back to the works. There were no lorries or even horses and carts – it was all manual labour in those days! The short Park Hill would be negotiated fairly easily and the gently sloping Roydon Road was no problem until the last hundred yards or so where the road slopes quite steeply down to the junction with the Holsworthy road, against which the works entrance was located. On this stage of the journey the unwieldy load would become very troublesome and Mr Northey and barrow would fairly hurtle down the slope and across the road into the workshop where their progress would be halted. It is a good job that in those days there was not the amount of traffic on the Holsworthy road that there is today – neither Mr Northey nor wheelbarrow and stone would have lasted very long!

Newport also had its own pub, the White Horse Inn, situated on the Square. Mrs Longman, wife of the landlord of The White Horse Inn, was another familiar and popular figure in the Newport area. A friendly, jolly character, she would be seen most mornings sweeping or scrubbing the steps from the hostelry's main entrance and would greet everyone who passed. One of the passers-by would be this writer's mother, pushing yours truly in a pram or pushchair. Mrs Longman had a great love for children and would stop her work to talk to the baby. The story always told was that Mrs Longman would inevitably exclaim 'that baby's as sharp as a packet of needles', which my mother took as a great compliment. In later years we asked Mrs Longman about this famous comment and she, dear soul that she was, replied, 'and she still is', which was a tremendous boost to my ego!

In short, Newport was a thriving community, but in 2009 only St Thomas church, a Methodist chapel and two shops remain. The 'tiddley' shop is now a Spar convenience store, the post office has been closed and other former shops are now private dwellings.

At St Stephens there was another church, an underground reservoir, a terrace of houses built by the Royal British Legion to accommodate wounded ex-servicemen, and for relaxation, a golf course. Like Newport it was a little tight knit community all of its own, and like Newport it no longer retains many of its distinct businesses and services.

In days gone by in small towns and villages in Cornwall it was customary for people to exchange greetings in the street, whether or not they were known to each

other. Walkers on country roads or lanes would usually engage in conversation about the weather. In small towns strangers greeted each other with a 'good day' or 'good morning' if they had perhaps seen each other before in a shop, at a funeral perhaps, or even just walking the dog. On country roads waves were always exchanged with those on horseback or driving horse-drawn vehicles or farm machinery. It would be considered very rude and discourteous not to do so, even if you never ever saw the person again or had never seen them before. Nowadays a wave to a stranger will usually only be greeted with a stony glare; how times have changed in a lifetime!

At one time every village and small town had its 'characters': people who stood out because of their eccentricity or their record of public service, or simply for the love of their fellow citizens that made them everybody's friend, and Launceston was no exception. Today most of those people are just living legends, passed on from this world but not forgotten by those old enough to remember them and, in fact, passed down as a part of local history. To the many newcomers in the area they mean nothing but generations of Launcestonians now and to come do and will remember them.

Just such a character in Launceston was Albert Clark. Small of stature but brimming with enthusiasm and totally devoid of shyness, his mission in advancing years was selling programmes for his beloved annual town carnival. Before the days of television and all the other modern technology, Launceston Carnival was the highlight of the year. It was a day of excitement for the town, from the afternoon crowning in the town hall of the Carnival Queen to the final minutes of carnival day, as the last revellers made their way home. People travelled from all outlying districts for the events and all roads into the town on carnival night were very busy, with traffic from late afternoon onwards and crowds gathering in the Square and along the route. For this big event Albert was a kingpin. He would patrol the Square and adjoining streets, a bundle of programmes in his hand and more in a bag slung over his shoulder, indiscriminately approaching all passers-by with the question 'Programme?' He had plenty of 'customers' and sometimes people were targeted more than once but they often bought a programme even if they already had one or two, just because it was Albert and he *was* Launceston!

Two other carnival stalwarts were the Misses Mary and Maud Parnell who took part in the walking section of the procession without fail every year until both were of very advanced years. Even after Mary died, Maud still continued their tradition until she too passed on. Their costumes were entirely home-made from whatever they were able to glean at jumble sales and they did show remarkable ingenuity in their outfits, often winning prizes in their class. They usually received bursts of clapping from onlookers as they passed.

Characters like Albert, Mary and Maud were 'one-offs', remarkable characters of a bygone age; gone from the scene today but not forgotten by older Launcestonians, still remembered and respected to this day. They made Launceston the unique and delightful place it was. May they rest in peace and know they are never forgotten. How excited and amazed they would have been if they had known that they would one day be mentioned in a book.

The photographs on the next few pages give just a taste of community life in and around Launceston through the years.

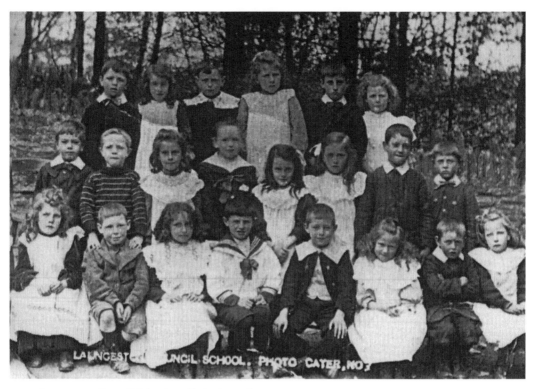

Launceston Council School pupils in the early 1900s.

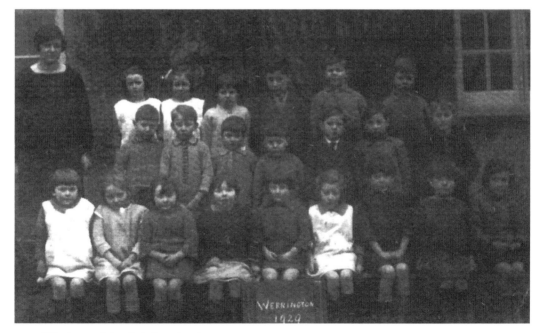

Werrington School's infant class in 1929.

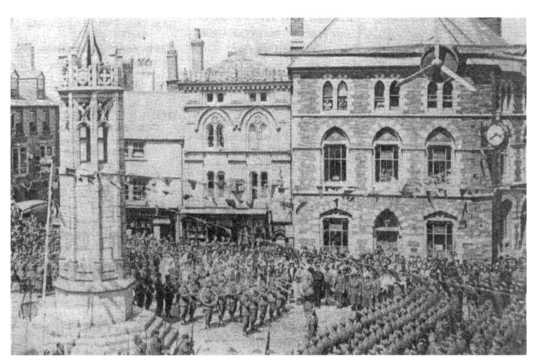

During the Second World War US Army troops were stationed in Launceston. A US army band is seen taking part in a National Savings 'Wings For Victory' parade in Launceston square, 12 June 1943. This scene look peaceful enough, but it was only three months later, in September 1943, that trouble erupted. Legend has it that the black and white soldiers had some sort of disagreement about the segregated dances. Trouble flared and shots were fired. The military police were called and arrests were made, in what has become known as the 'Battle of Launceston'. Until recent years some older residents could still indicate bullet holes in some of the shop fronts.

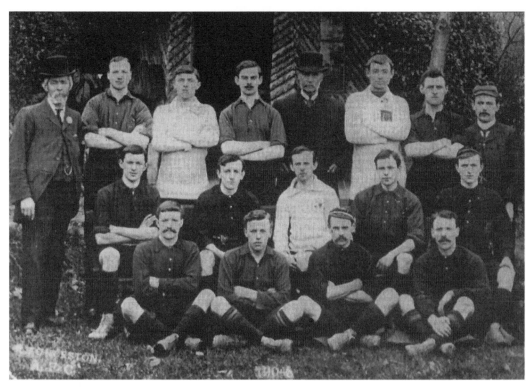

Launceston Association Football Club in 1904.

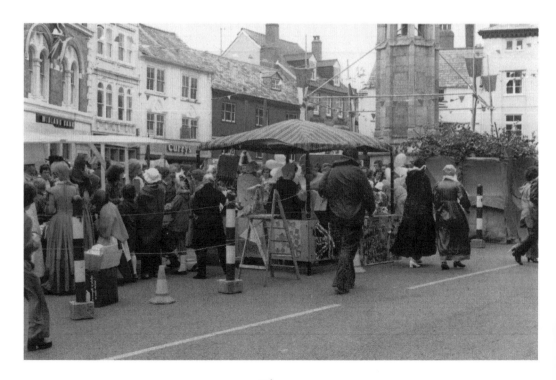

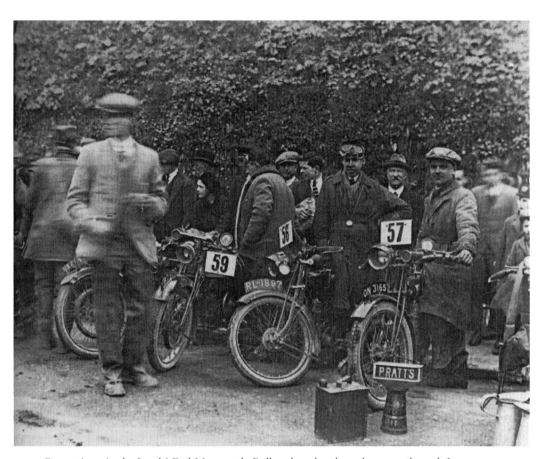

Competitors in the Lands' End Motorcycle Rally take a break as they pass through Launceston in the 1930s. The late Mr Stan Wooldridge of Launceston is pictured (no. 57). Note the advertisement for Pratt's Motor Oil positioned in front of him and his machine. He was a regular and successful competitor in the rally for many years. He ran a van and motorcycle dealership as well as a garage in the town.

Opposite below: This picture shows a general view of the Elizabethan Fayre of 1977. The Fayre was opened by the Mayor, Alan Buckingham, and the Town Clerk, heralded by the town band. During the day there were various attractions, including stalls with the vendors dressed in period costume, and side shows in the square. There was also the execution of a witch on the castle green, a 'Drake's bowls' match and excerpts of Shakespeare performed by the Launceston College Players. The Southgate Arch was opened as a chamber of horrors, showing the kinds of punishments that were used in the town in times gone by. There were other interesting historical displays also: St Mary Magdalene church showed its plate, vestments and registers, the Guildhall shared the town archives and regalia, and Lawrence House Museum put on a display of Elizabethan costume. The day ended with an Elizabethan-style 'Beat Dance' in the town hall. (Photograph: John Neale collection)

The traditional Boxing Day meeting of the fox hounds in the square, in around 1920, which is being viewed by the 'hart' over the White Hart hotel doorway. There is not a protester in sight.

Opposite: For the Roman Catholic community in Launceston, 1977 was a special year – the 400th anniversary of the martyrdom of Cuthbert Mayne in the town square. Later he was canonised and became St Cuthbert Mayne. At this time the dedication of the Roman Catholic church in St Stephen's hill was changed from the church of the English Martyrs to the church of St Cuthbert Mayne. In 1921 an annual pilgrimage to remember Cuthbert Mayne was inaugurated by Father R. A. McElroy. Held in June each year the pilgrimage day became known as 'Catholic Sunday' and was for many years a highlight of the town calendar, bringing thousands of Roman Catholics to the town from over a vast area. Poeple of all denominations would line the streets to witness the procession. This photograph shows the procession leaving the square, carrying in remembrance the sacred relic – part of the skull of the martyr. Among those pictured are Father Gilbey, Roman Catholic Priest in Launceston, Cardinal Basil Hume, Mrs Cynthia Buckingham, Mayor of Launceston, and other town councillors. To mark the even a slate memorial plaque was unveiled by the north gate of Castle Green by Cardinal Hume, accompanied by Father Crystal, secretary to the Bishop of Plymouth, and Father Bede Davis, one-time Catholic Priest at Launceston. (Photograph: John Neale collection)

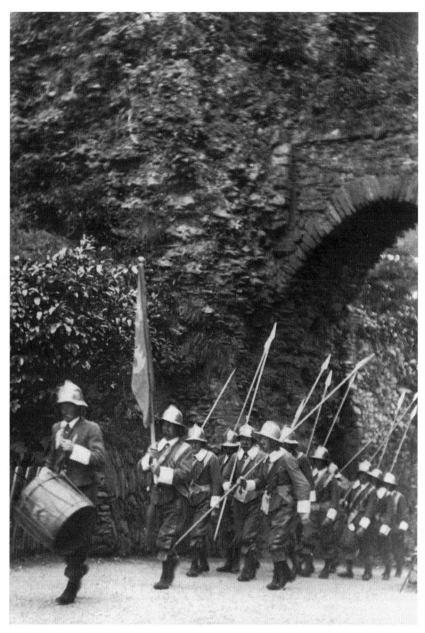

Launceston has a long and proud history, which fired the imagination of Miss Mary Kelly. She wrote a pageant in five episodes, which depicted historical events in the town between 1089 and 1862. The play was produced by Mrs Evans and performances took place on Castle Green in the summer of 1931. Apparently there was a cast of some 400 people, who threw themselves into the production with enthusiasm. This photograph is of Scene Four, the entry of Grenville's men during the Civil War. By all accounts all the costumes and many of the props were made by members of the cast or sourced locally, to keep expenses down. (Photograph: John Neale collection)

3

Transport

Crowds gather at Treleaven's corner in 1910 to see the first mechanical tricycle driven through town.

From the days when the clip-clop of horses' hooves was the loudest noise in the streets to the present, when RAF jet planes roar overhead at such a speed that they have come and gone before they can be seen, Launceston has changed immensely over the years, and is still expanding, pushing ever-outwards over green fields as housing estates 'mushroom'. It seems almost inconceivable that horses and jet planes are both normal occurrences just in the lifetime of this writer but that is the case, such is the rate of progress in a quiet Cornish market town.

Right up to the 1950s and '60s horse transport was still utilised in the town. Traders used horse power for deliveries of all manner of products. Mr Robbins the butcher had a large open-backed van for his mobile butcher's shop on his country rounds and when he was making deliveries the horse would break into a canter on straight sections of road and the joints of meat hanging from hooks in the van

would swing wildly. One lady always said that she expected she would one day have her Sunday joint for free because she would find a joint of meat lying in the road!

Chaplins the carrier's had a large horse-drawn wagon. They collected goods sent by rail and delivered them to local addresses. The young man who drove the wagon would often stand up behind the shafts to drive his heavy load. Garlands the baker's used a trap-like cart for deliveries, with the bread contained in large hand-baskets to be carried to the customers' doors. The horse buses of both the White Hart and Castle Hotels met passengers off all the trains until the horse buses were replaced with motorised ones in 1928, and in the 1920s the horse-drawn Post Office mail cart met trains to collect mailbags.

This picture shows Launceston town Mayor, Councillor Jim Hughes, setting off in grand style from outside the White Hart hotel to visit the Centenary Launceston Agricultural Show, still fondly known as the 'horse show', in 1987. Despite the rain, the vast crowd gave a rapturous welcome to the little Welshman, who some say was an honorary Launcestonian if ever there was one. It was army service that brought Jim Hughes to Cornwall; he was in charge of the German and Italian prisoners of war at nearby Werrington Park. He joined the town council in 1957 and held his seat for thirty-seven years. Jim 'Taffy' Hughes, who hailed from Aberdare in Glamorgan, was three times Mayor of Launceston. He died in July 1996. The four greys and the stagecoach were the pride and joy of Mr William Tucker. (Photograph: John Neale collection)

Miss Gurney and her dog going for a ride in her donkey cart.

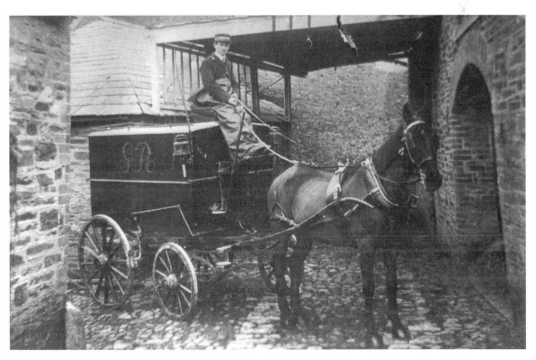

The horse-drawn Post Office mail cart, used to collect and transport mail from the trains.

This picture shows Joe Vidler, who was a popular figure, with Trixie, whom he bought for one hundred pounds to rescue her from certain slaughter. He is shown here with his equipage at the junction of Dunheved Road and Police Station Hill at the end of Westgate Street. Originally from Kent, Joe, who died in 1989, came to Launceston where he later married and settled. Later he became a fireman and a member of St Mary Magdalene church choir for many years. At one time he ran a furniture removal and storage business based in St Thomas Road. Joe and his 'Turnout', as he liked to call it, were always popular attractions at the Launceston Agricultural Show, and also at the Launceston Steam and Vintage Vehicle Rally, then held at Polson. (Photograph: John Neale collection)

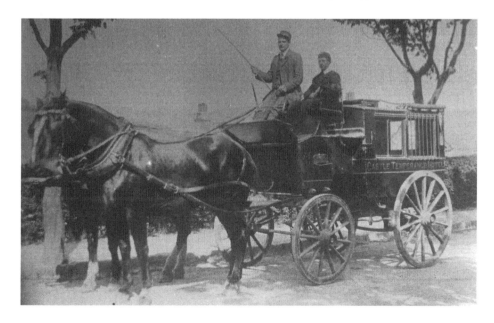

The railway went to Exeter and beyond, and from Launceston continued westwards to Padstow. The station played host to the prestigious *Atlantic Coast Express*, which carried thousands of holidaymakers to and from the North Cornish coastal resorts.

The demise of the railway in Launceston is still lamented by those who remember it in its heyday; it had such a long history in the town. It was in 1865 that the branch terminus of the Launceston and South Devon Railway from Tavistock to Launceston was formally opened. In 1885 the London and South Western Railway through-station of the North Cornwall line was constructed to the south of the site.

In 1878 the Launceston and South Devon Railway was taken over by the Great Western Railway and in 1880 the LSW railway inaugurated its first passenger traffic. The year 1892 saw the end of the broad gauge era for the Tavistock–Launceston line. Cattle were driven through the streets to both stations and loaded into railway wagons to go all over the country. Likewise cattle were brought in by train and accommodated overnight in a field almost adjacent to the GWR station before being transferred to their new homes.

The last train from Plymouth to Launceston each day remained in the station overnight and those catching it on its first outward journey at 7.15 a.m. each winter morning had a chilly journey. The carriage windows were often frosted over and the heating did not really penetrate much before the train reached Plymouth!

It is perhaps difficult today to fully appreciate the important part the railway played in the lives of ordinary people in Launceston and the surrounding area.

For instance, all the newspapers came to Launceston by rail and the Plymouth evening daily, the *Evening Herald*, came up on the last tram each evening and newsagent Mr Vosper, who lived near the station, went there every evening to collect the papers to deliver to his customers around the town. Saturday was the busiest evening. Groups of men would gather at the station awaiting the arrival of what was popularly known as the *Football Herald*, all anxious to learn how Plymouth Argyle and other local teams had fared. In the 1930 and '40s there was no television as we know it today and many households did not even have radios, so papers were the only way to find out what was going on in the world.

During the Second World War both railways were of vital importance. The US Army constructed a huge railhead at Halwill, some miles from Launceston, into which troops poured, as well as supplies of all kinds, and which serviced all the US Army camps in North Cornwall. It was busy day and night and illuminated by huge floodlights, although in the blackout hours these could not be operated.

After the war, holiday travel to the North Cornwall coast started again and the many small stations on the line to Padstow were very busy with local traffic as people travelled to and from Launceston to go to work or otherwise conduct their business.

Opposite below: The Castle Temperance Hotel horse bus met all passengers leaving trains at Launceston station, but it gave priority to those staying at the hotel.

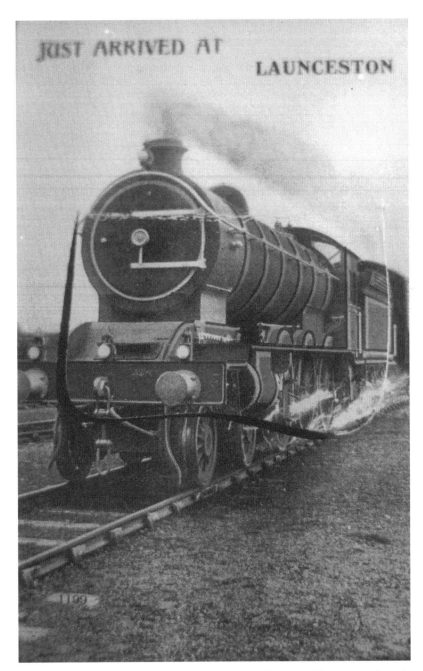

JUST ARRIVED AT LAUNCESTON

Freight was large part of the railways' function in the town. All manner of goods were carried, from cattle or heavy machinery to small parcels. Rabbit trappers and dealers in the area used to bring in crates of rabbits destined for London markets, especially during the Second World War when meat was rationed. The train also served another purpose. People in the vicinity would wait to hear the train whistle at Egloskerry before leaving their homes to catch the up-train on the Southern line. They could tell the time by that signal, as the train was so reliable.

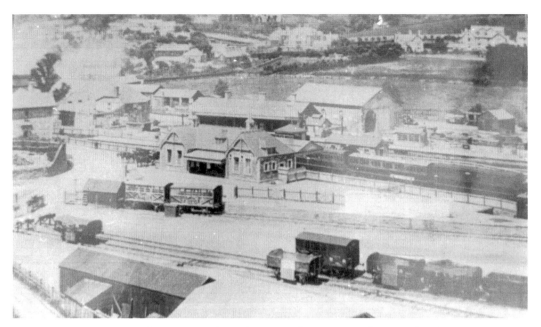

This photograph may be from as early as the 1890s, showing the railways in their heyday.

Both Launceston stations were run very efficiently and had a good safety record. There was, however, one little tragedy that is remembered even to this day by surviving railwaymen who worked at the station. The station's pet cat, known affectionately as 'Granny', had lived almost all of her long life at the station and was known by all the railwaymen on the Launceston–Padstow line. Early in March 1958, Granny was killed by the early morning freight train at Launceston Station. No doubt at her very advanced age her sight and hearing were failing. Her passing caused much sorrow; many regular passengers had also known her for years. She was accorded a full railway funeral, being cremated in the firebox of an engine, and there was a tear in the eye of many a tough man that day. Granny was twenty-one years old when she died – a very old friend indeed to many people.

It is no exaggeration to say that the railways were the life blood of Launceston. Their closure was regarded as a disaster for the town and many people are still of the same opinion today.

The two stations were demolished and built over as part of a new industrial estate. However, the Southern Railway's North Cornwall line has had a partial reprieve since the Launceston Steam Railway narrow gauge operation was started by a private entrepreneur. It runs over several miles of the old SR track towards Egloskerry and is a popular tourist attraction. But nothing can replace the majesty and dignity of the great green engines of the *Atlantic Coast Express* taking on water from the tank near the footbridge (of which only a few granite steps now remain on one side), after its long journey from Waterloo Station. The train actually split into several parts at both Exeter Queen Street Station and Halwill Junction, with parts going to north Devon and only one or two coaches going on to Padstow via Launceston. Nevertheless the coaches were generally packed with holidaymakers, business people and local residents bound for the small stations between Launceston and Padstow.

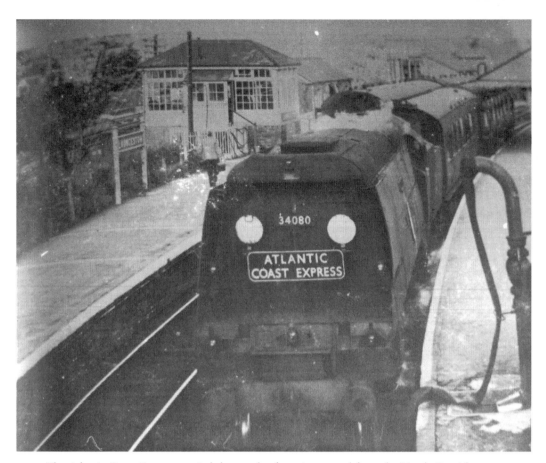

The *Atlantic Coast Express* carried thousands of tourists to and from the North Cornish coast. One could board a train in Launceston and go right through to London's Waterloo station without changing and the same applied in the opposite direction.

When Dr Beeching wielded his axe on the branch railways in the 1960s Launceston lost both its stations and road transport has never been able to make up for the blow.

View of the town and castle from Ridgegrove Lane in the 1980s. The railway and all associated buildings were gone by then. When the two stations were demolished they were built over as part of a new industrial estate.

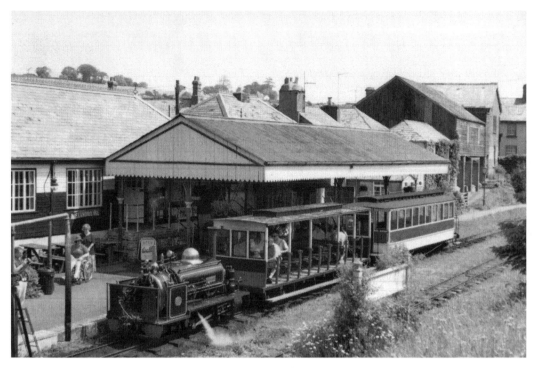

The Launceston Steam railway was the brainchild of Nigel Bowman from Surrey, who came to Launceston during his search for a suitable site for his enterprise. The disused British Railway line along the River Kensey valley fitted the bill. Initial approaches to the then County Council and the District Council were favourable and they gave their approval. Later the necessary Light Railway Order was obtained from Parliament. Several years later, after fighting off the developers, Nigel Bowman, his fellow directors and a veritable army of more-than-willing local volunteers had cleared the old station and the track bed of rubbish, cut back encroaching trees, and laid the all-important line. The steam railway's first locomotive was *Lilian*, a narrow gauge, 8-ton engine built in 1883 by the Hunslet Engine Company of Leeds. She was found dumped behind some workshops at the Penrhyn slate quarry in Wales, waiting to be scrapped. Fortunately she was rescued at a cost of around £60 – by all accounts the copper boiler was of great value. *Lilian* hauled the first train carrying fare-paying passengers along the River Kensey valley on Boxing Day 1983. Since that day the Launceston Steam Railway has never looked back. The enterprise has been totally self-sufficient from the outset. Everything required for maintenance is made in its own workshops and it has never borrowed nor owed a single penny to anyone. (Photograph: John Neale collection)

Opposite below: Passengers ready to follow *Lilian* through the picturesque River Kensey valley to Newmills. The carriages, each carrying forty passengers, were built in the Steam Railway's own workshops to an 1893 design based on the 'toast racks' of the Manx Electric Railway in the Isle of Man. On summer evenings, with the wind in the right direction *Lilian*'s whistle can be heard up in the town centre as she rumbles along the Kensey valley, bringing another train of delighted passengers safely back to Newport. It is a sound which fills many locals with nostalgia.

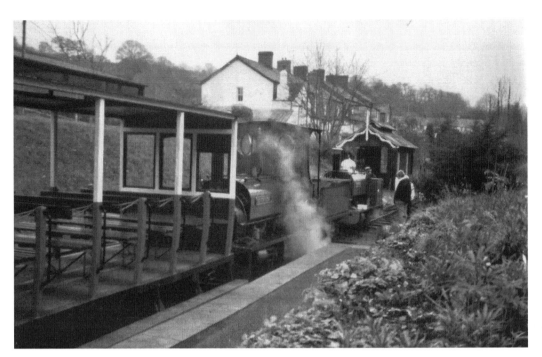

The Launceston Steam Railway has turned from being one man's pipedream of owning a narrow gauge railway and small museum into the premier inland tourist attraction in north Cornwall, bringing several thousands of visitors to the town annually.

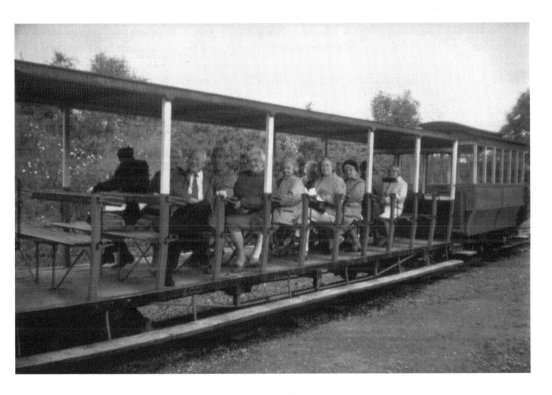

Launceston has a good network of roads including the bypass, which forms part of the A30 spine road that runs the length of Cornwall, but it was not always so. The medieval Royal Duchy Road was little more than a cart track, despite its grand name, and other roads were barely more than green lanes.

However, it all began to change in the eighteenth century with the advent of turnpike roads. Turnpike Trusts were formed to administer certain roads or groups of roads and had the power to levy tolls and borrow money on the security of the tolls they raised. A General Turnpike Act was passed in 1773 and Launceston was right on the ball and had already established such a Trust in 1760. Charges ranged from 1½d (threehalfpence) for a horse, mule or ass unladen and not drawing any vehicle, 3d (threepence) for a yoke of oxen, up to 10d (tenpence) for a carriage, wagon or cart with four wheels. The appropriate sum had to be paid at the toll-gate before the traffic could proceed.

The scheme was highly unpopular and people went to great lengths to avoid paying a toll. The objections often resulted in gross abuse of the rules and frequently ended in court cases. One memorable case, widely reported in the local press at the time, was that of Mr John Tubb, a farmer of Newchurches, St Stephens, who was summoned by Launceston County Magistrates for refusing to pay a toll when riding a horse through St Stephens Gate. He claimed exemption on the grounds that he was going to see the cattle on a portion of his farm and that he had not passed over one hundred yards of road when the toll was demanded. He vehemently declared that he had come by a parish road that adjoined the toll-gate – but finally admitted going over one hundred yards of the turnpike road after passing the gate.

Despite Mr Tubb being represented by a lawyer the bench decided that he was liable to pay the toll of 1½d and declared there was no exemption when riding cattle from pasture but going to plough or harrow was exempt. The costs in the case amounted to the princely sum of 14s 6d (about 75p in today's money)! The fuss over such paltry sums may appear ludicrous today, but in those days a farm worker's wages would be in shillings and pence, and pounds were an unimaginable fortune, so the costs of 14s 6d were astounding in their enormity.

Even well-to-do people often tried to dodge paying. There are several recorded cases of men then classed as 'gentlemen' – being professional or of independent means – being caught trying to evade the payment of tolls, and a clergyman was found guilty on one occasion. In addition there were many cases for compensation from people claiming that the road building had damaged their land. It is a wonder, then, that the tolls ever made enough to cover their costs in upkeep of the roads! We may laugh about it today, but in modern times there are always protests when the tolls on the Tamar road bridge at Saltash are increased. Nothing ever changes, least of all human nature!

The toll-house on Dutson on the Launceston to Holsworthy road. It is now a private dwelling. The money received from the tolls paid for the maintenance of the roads.

Although Launceston is an inland town and has no navigable river it had links with water transport through the construction of the Bude Canal in the nineteenth century, which played an important part in the industries of the time.

The canal was the brainchild of two landowners in North Cornwall, Messrs Braddon and Harward. Both were highly respected men, although Mr Harward had been 'whispered' to be involved in clandestine smuggling operations – such activity was rife at this time and no one was above suspicion. It was also the time when the canal age was getting into full swing and entrepreneurs were greedily contemplating the cash that such enterprises could generate.

Nevertheless, Messrs Braddon and Harward had the most charitable motives. They were both concerned about the dangerous levels of unemployment and potential destitution for men returning from the Napoleonic Wars who faced a bleak future. They conceived that the construction of a canal would provide work for the men and would also be beneficial to local trades, most especially to those with farming interests.

The two men got the blessing and support of Lord Stanhope, a considerable landowner in North Devon, through much of whose land the canal would run, and the way seemed clear for the project to go ahead. The original idea was for the canal to be used to transport mineral-rich Bude sea sand to the hinterland to be used as fertiliser on the soil, much of which was of poor quality and would benefit greatly from such a dressing. However, the Act of Parliament passed in 1774 'for making a navigable Cut or Canal from the Port or Harbour of Bude in the Hundred of Stratton in the County of Cornwall to the River Tamar in the Parish of Calstock near to the town of Launceston in the said County' stipulated that 'slate, stone, sand, culm, coals, timber, bricks and any kind of manure or fuel' could be carried and it added that 'the chief commodity of traffic would be coals from Wales' – not exactly what the originators of the idea had envisaged. During the whole of its working existence the canal was used for trade, the only recreational use being for people who skated on it when it was frozen over in the winter!

The original Act of Parliament called for the canal to continue to Trewen, Egloskerry, the Parishes of St Thomas the Apostle and St Mary Magdalene, Launceston, to South Petherwin, Laneast, St Clether, Altarnun, Lewannick, North Hill, Linkinhorne, and so to Calstock. It was really far too ambitious and would have covered a vast expanse of territory, but those early entrepreneurs were ambitious men. Perhaps it may have achieved the original objective in the long run if the railway had not come when it did – we shall never know.

In the event the canal hit an early hurdle when a map prepared by engineer James Green was 'leaked' before construction could be completed. It showed the canal passing through Werrington Park, then owned by the Duke of Northumberland, and being carried on an embankment very close to the Duke's mansion. As a result of this the Duke immediately and totally denied access to the canal across any of his land, which virtually upset the whole scheme. The canal was forced to terminate at Druxton, far short of its original goal, but well clear of Werrington Park, and it was impossible for it to continue to the proposed termination point.

Nevertheless, the canal proved a very viable venture and flourished for a number of years, transporting all manner of goods, even livestock. It operated with a system of incline planes and was revolutionary at the time in its mode of construction. It has since been described as being a feat of engineering before its time. Certainly

there were snags: there was human error and there were engineering failures, some of the machinery did not live up to the aspirations of its inventors, and yet, somehow, the canal survived all setbacks and proved very advantageous for the industries of Launceston and district at the time.

It was the coming of the railway that killed the canal and it finally closed down in 1891 after a period of instability but hope for the future, which unfortunately faded as the railways grew. Many of the canal's former employees, who started work as young boys, totally unskilled, lived on into modem times and could recall the canal being a thriving waterway; the last of them, Mr Walter Smith of Druxton, Werrington, died in 1959 at the age of eighty-one years. The Canal Age, as far as North Cornwall was concerned, was dead forever, never to be resuscitated. The canal opened in a fanfare of publicity, but it died with barely a whimper.

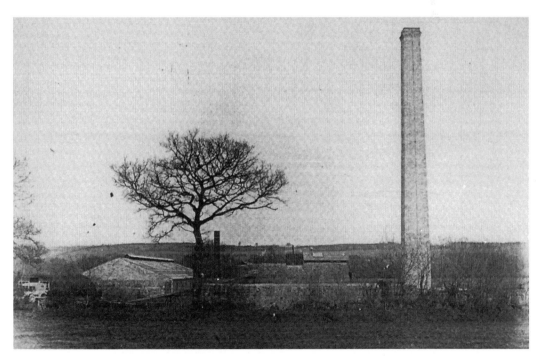

The former brickworks at Dutson, which closed prior to the Second World War. It made bricks for, among other new constructions, the Bude Canal.

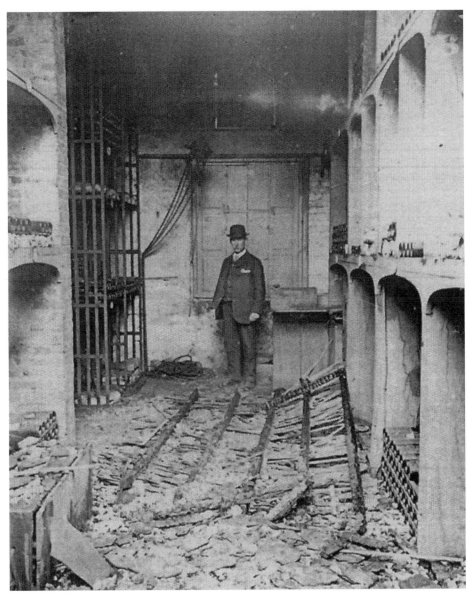

The manager of the brickworks surveys the devastation during the demolition. Piles of drainpipes made at the works are still stored in the niches.

Polson, or Polston Bridge, spanning the River Tamar a mile or so from Launceston, is one of the ancient routes into Cornwall. It had three main arches, each 17 feet in span, and three floodwater arches. In 1446 the Bishop of Exeter visited Launceston and was apparently so pleased with the entertainment laid on that he granted an indulgence of forty days 'for the repair of Poulston Brygge'. At one time, when the court judges were on circuit a watch was stationed on St Mary Magdalene's church tower, so that when the judge approached the bridge the town dignitaries could be alerted to prepare to greet the great man. During the Civil War Polson Bridge was the scene of skirmishes between Royalist and Parliamentarian forces. In 1809 the bridge was only 19½ feet wide, with a long causeway approach. In the nineteenth century Launceston was a parole town and the centre of Polson Bridge marked the limit of the parole area. Prisoners who overstepped the mark could be sent back to Dartmoor prison. Local people who saw a prisoner break his parole could report him and claim award, and apparently it was not unknown for local people to entice unsuspecting convicts across the bridge for precisely this purpose!

In the middle of the nineteenth century a new bridge was built at Polson. William of Worcester records that the old bridge was built at public expense and was 'a large fair stone fabric', but seemingly there was a weakness in the structure. During Victorian times half the bridge was torn down, leaving only the three floodwater arches on the Cornish bank that were later incorporated into the rebuild. This was an iron girder affair, reinforced with concrete and faced with stone. At one time the Duke of Cornwall was met at Polson Bridge whenever he came to the duchy and the feudal dues were presented. A highlight for Polson Bridge was the 1997 Keskerdh Kernow 500 March to mark the Cornish uprising against the king in 1497. The marchers crossed the Polson Bridge from Cornwall into Devon with banners and flags flying, on their long trek to Blackheath. Polson Bridge has been somewhat relegated to secondary importance since the construction of the Dunheved Bridge which carries the Launceston bypass over the Tamar.

Opposite below: A short distance below Polson Bridge there was Chain Bridge. There are several deep pools nearby, so the spot became popular for picnics and swimming. The bridge was constructed of chains slung across the river and separate wooden slats fastened to the main linkage with shorter chains, all of which was kept in place by large stone bases. It is fair to suggest that this bridge was the flimsiest crossing anywhere on the river. It was not unusual to see chain bridge festooned with debris that had been carried downstream by the rising water. The bridge was completely destroyed several years ago during the winter floods.

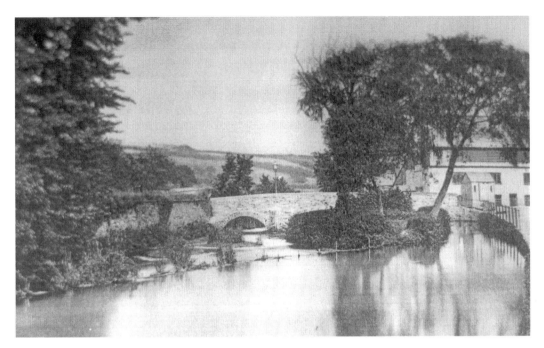

Road bridge over the Kensey from Hender's Tannery, 1930s.

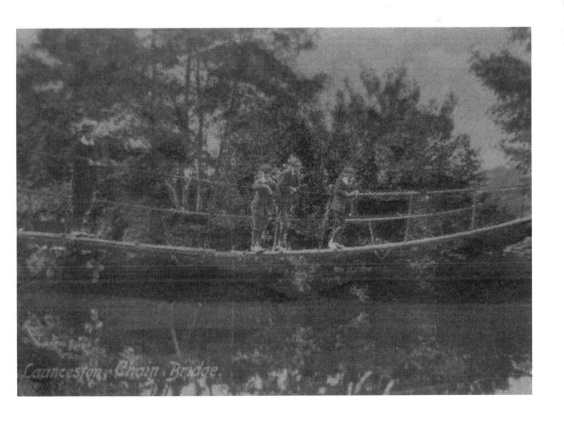

As yet Launceston does not have an airport and there seems little likelihood of one being constructed in the foreseeable future, but its residents are very much air travel minded and many often shun slower forms of transport now. It seems no time ago that the first aeroplane flew over the town in the early 1930s; it caused a sensation. People rushed out of their homes to see this new wonder and this writer can well remember standing in the front garden of a relative's home at Newport and watching the biplane flying above the castle: it was an experience never forgotten to this day and the sight can always be recalled in memory. We had no instant cameras or mobile phones to record great events in those days!

Motor transport came slowly to Launceston. Some well-to-do people invested in motor cars while others preferred their horse-drawn carriages of various kinds and used them right up to the time of the Second World War and beyond. One lady of 'country gentry' stock was appalled at the idea of travelling in anything but her elegant landau and continued to do so throughout her life. In the country parishes, postmen delivered the mail riding official Post Office bicycles right up to the 1960s when they were replaced by postmen in vans, the mail being brought direct from the sorting office at Launceston instead of being sorted and delivered from village post offices, many of which were soon to close.

Few Launcestonians can forget the late Mr 'Herbie' Sandercock driving his horse and trap at 'breakneck' speed through Launceston Square with his dog running beneath the trap and Mr Sandercock waving his whip to everyone who knew him – and everybody did know him. Cars were not always the ambition of all private individuals either, especially in the country parishes. One dear old couple who lived near this writer went to market every Tuesday in a pony and jingle. The husband was a big, burly man and when they came to the long hill from Yeolmbridge to St Stephens the wife would take the reins and her husband would get out and walk until they got to the top of the hill, because they felt the heavy load was too much for their small pony to cope with on the hill!

Public transport by road also evolved slowly. Mr Rickard's horse bus plied between Launceston and Callington up to the end of the 1930s and such motor buses as there were could be described as somewhat Spartan at the least.

It is perhaps kinder to draw a veil over public road transport in Launceston in the twenty-first century. From being a boom industry in the 1900s it all but disappeared and the proliferation of private cars on the roads and in the town became something of a problem rather than a boon. In a small, tightly packed town there can be only so much space to park cars and, despite the building of a very controversial multi-storey car park in the late twentieth century, that space soon began to run out.

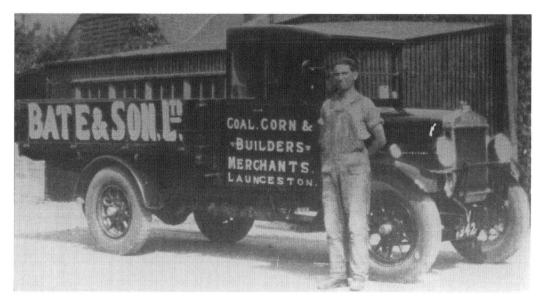

Mr Tom Jenkins with an early motor lorry. Not everyone was so quick to move to motor power, however. Garlands, the bakers in town, delivered the bread with a horse and trap. Butchers, carriers and all manner of business people, including one of the local vets, still made deliveries or went about their business by horse power.

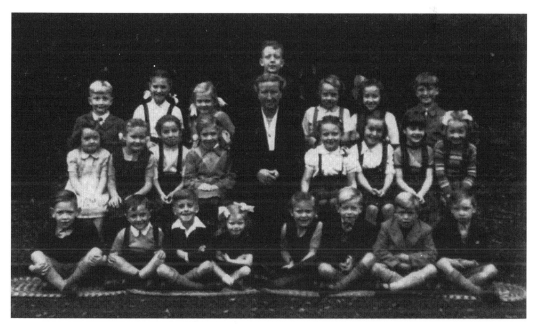

Popular local teacher the late Miss Mabel Maddever with her class of South Petherwin School in the 1940s. When she took to the roads in a Baby Austin car it was a sensation and was considered quite revolutionary. Miss Maddever was a far-seeing lady who wanted to become part of modern life and she saw that the days of horse transport would soon be little more than a memory.

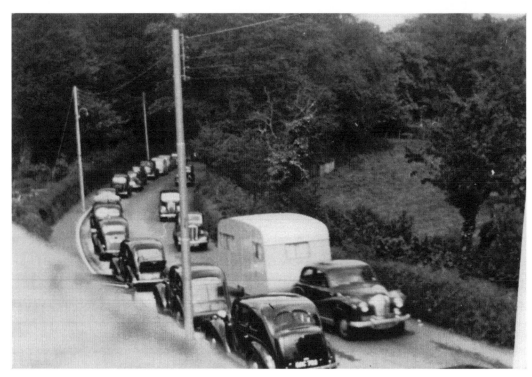

At one time, traffic queues on the A30 trunk road through Launceston were horrendous, particularly during the summer months. Vehicles would be crawling nose-to-tail through Kensey, grinding round Prout's Corner and along Tavistock Road in seemingly endless tailbacks, as seen in this picture looking down on the road from above Kensey. This problem was only alleviated by the town bypass from Lifton Down to Tresmarrow, which was built by McAlpine & Son and opened in 1976. Among the first to travel along the bypass were Mr and Mrs Wilfred Bailey, Mayor and Mayoress of Launceston. They were followed by countless local people, all eager to experience the new route! It was believed at the time that by siphoning off the juggernauts, traffic in the town would be eased. However, there is still considerable congestion, and at the time of writing a new traffic flow strategy for the town is under discussion. (Photograph: John Neale collection)

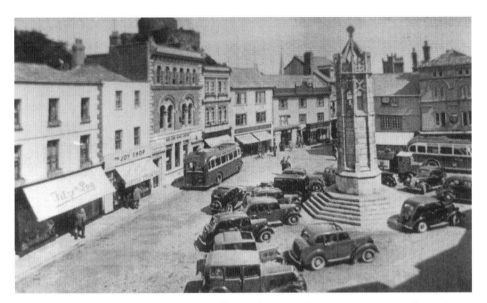

Launceston square *c. 1939*, with motor traffic. No long-standing Launcestonian will ever forget Tom Sandercock. He was a traffic warden who controlled the traffic at Treleaven's Corner. Before the bypass existed, all traffic, including coaches, buses and lorries, had to go through the Square, negotiate the difficult corner where Tom was stationed and then pass through the Southgate, which often caused problems. But Tom could always sort it out. He kept the traffic moving freely and was a huge asset to the town. He was awarded a local honour by the town council for his efforts and never was an honour more deserved.

This image shows the junction of St John's Road and Woburn Road in Western Road, in 2002. At that time a new pedestrian crossing was being made and traffic lights were being installed. (John Neale collection)

From time to time the Launceston streetscape is unexpectedly brightened by the arrival of these Irish travellers, as shown in this picture, taken outside the White Hart Hotel. The music played by this talented young lady is much appreciated by shoppers. As yet there is not a traffic warden in sight! (Photograph: John Neale collection)

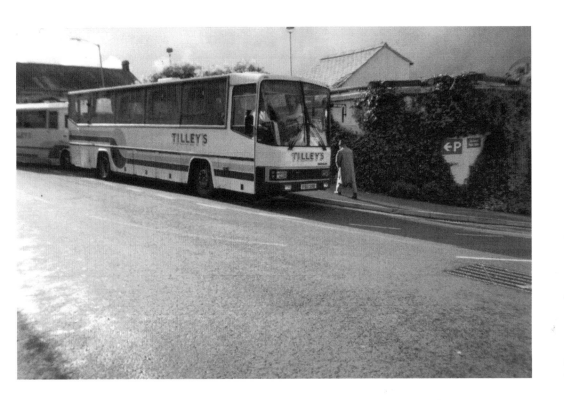

In the twentieth century, Launceston was well-served by buses and coaches. London was by then easily accessible by road and the brown and cream livery of the Highways Co. was a familiar sight in the town. The coaches left London each day in the morning and arrived in Launceston the same evening, dropping off passengers at places *en route*, and were very popular with long-distance travellers. The company was later taken over by the Royal Blue and they ran the latest luxury vehicles from London on a regular basis. The Royal Blue was succeeded by Western National and when the first double-deckers appeared at the town coach stop in the 1990s it was quite 'the thing' to take a trip on them for the experience of riding on the upper deck – although some people confessed to feeling slightly queasy at viewing the road and the countryside from such an elevated position! The green and cream buses of Western National ran just about everywhere and were a most convenient form of transport. Also, it was possible to send a parcel or any form of easily transportable goods somewhere by stopping the bus on the country road and handing the parcel to the conductor, who would issue a ticket for the amount paid. The parcel would be collected at a bus depot after its arrival, or the recipient would just stand in the road, flag down the bus and collect their parcel. It was extremely convenient but a facility that has gone forever now.

Several private bus operators ran local services around the villages in the area and even if the service was only a 'one-bus operation' from the operator's country garage it was very useful and much appreciated, making travelling in the immediate neighbourhood much easier for those without transport of their own. On market days several private operators' buses would be seen picking up and dropping off passengers in the Square.

Nostalgia is a strange thing, it can bring the past back to life and it can trigger emotions that otherwise remain hidden. This was never better illustrated than when in 2007, the West Country Historic Omnibus and Transport Trust (WHOTT) staged a rerun of Royal Blue coaches through Cornwall and parts of Devon, using vintage vehicles now owned by its members. When the small convoy came through Launceston (always one of its strongholds for passenger numbers) several tears were surreptitiously wiped away as the little procession of coaches passed on their old route through the Square and under the arch of the Southgate.

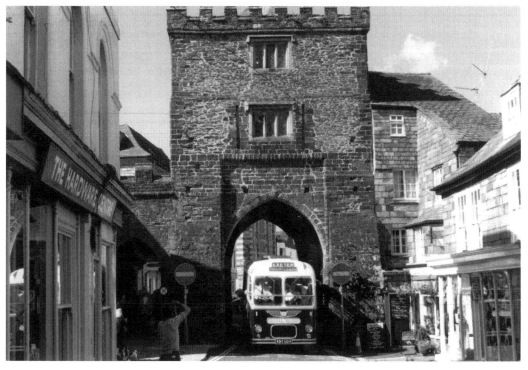

Once, the Royal Blue buses, popularly called 'The Blues', ran through Launceston daily. This image shows a Royal Blue bus passing under the arch during their anniversary tour in September 2005. (Photograph: John Neale collection)

DISCOVERING THE
RIVER TAMAR

JOHN NEALE

Discovering the River Tamar
John Neale

A fascinating journey along the river through the history and folklore
of the Tamar, one of Britain's most beautiful and enchanting rivers.

978 1 84868 866 7
160 pages, black & white

DEREK TAIT

RIVER TAMAR

THROUGH TIME

River Tamar Through Time

Derek Tait

This fascinating selection of photographs traces some of the many
ways in which the River Tamar has changed and developed over the
last century.

978 1 4456 0518 0

96 pages, full colour

Available from all good bookshops or order direct
from our website www.amberleybooks.com